IMAGES of America
VIRGINIA CITY AND THE BIG BONANZA

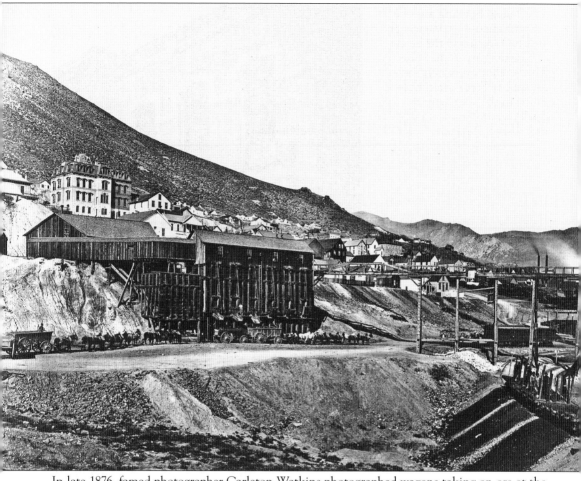

In late 1876, famed photographer Carleton Watkins photographed wagons taking on ore at the Chollar Mine for transfer to a mill. The Fourth Ward School, built for 1,000 students, stands above. The four-story, Second Empire–style building served the fourth political subdivision of Virginia City. Its east facade was still not completely painted before its opening in January 1877. (State Historic Preservation Office.)

ON THE COVER: On April 29, 1898, seniors from Virginia City's Fourth Ward School hosted their counterparts from Reno's Central School as they toured a hoist house, the place where miners descended down shafts to underground works. Famed Reno educator Mary S. Doten, the daughter of Comstock journalist Alfred Doten, is seated at center. Holding miner's lamps, students donned work jackets and caps for their tour of the underground excavations. (Historic Fourth Ward School Museum.)

IMAGES of America
VIRGINIA CITY AND THE BIG BONANZA

Ronald M. James and Susan A. James

Copyright © 2009 by Ronald M. James and Susan A. James
ISBN 978-0-7385-6970-3

Published by Arcadia Publishing
Charleston, South Carolina

Printed in the United States of America

Library of Congress Catalog Card Number: 2008938273

For all general information contact Arcadia Publishing at:
Telephone 843-853-2070
Fax 843-853-0044
E-mail sales@arcadiapublishing.com
For customer service and orders:
Toll-Free 1-888-313-2665

Visit us on the Internet at www.arcadiapublishing.com

*To all Comstockers—past and present—in honor of the
150th anniversary of the 1859 gold and silver strikes.*

CONTENTS

Acknowledgments		6
Introduction		7
1.	The First Boom: Virginia City Is Born	9
2.	The Towns: Thriving Communities Welcome the World	23
3.	Building the Place: Making the Comstock Livable	41
4.	The Big Bonanza: The Great Mines	69
5.	The Mills: Technological Achievements	79
6.	Education: From Mining Camp to Family Town	87
7.	*Borrasca*: Virginia City Barely Hangs On	99
8.	Celebrating the Wild West: Virginia City Welcomes the World Again	113
Bibliography		127

ACKNOWLEDGMENTS

This book celebrates images from two large collections. For over 20 years, photographs have found their way to the archives of the Historic Fourth Ward School Museum, and unless otherwise noted, the images presented here draw from that repository. Under the outstanding leadership of executive director Barbara Mackey, this remarkable institution honors an extraordinary past and preserves one of the most significant remnants of educational history in the West. In addition, museum archivist Cindy Southerland has worked to create an outstanding research facility. The authors appreciate their generous support of this project.

The Walter M. Mulcahy Collection, housed at the offices of the Comstock Historic District Commission, represents a second important source of images for this publication. For decades, Walt Mulcahy (1907–1991), a history enthusiast noted for his devotion to the remnants of Nevada's past, photographed the state's fading relics. In the 1970s, Mulcahy donated a sizeable collection of his work to the Comstock Historic District Commission. Photographs that he took from the 1930s to the 1950s are indicated with the attribution of Mulcahy-CHDC. Other images from the commission are indicated by CHDC. Thanks go to Michael "Bert" Bedeau, district administrator, and the Comstock Historic District Commission.

A few photographs come from the collection of the State Historic Preservation Office (SHPO). In this context, the authors wish to thank John McCarthy as well as the late Don McBride and the Bucket of Blood Saloon for making several images available to us. In addition, a few images were obtained from the excellent online archives of the Library of Congress (LOC). Other sources of images include the private collection of the authors (JAMES), the Nevada State Library and Archives (NSLA), the Special Collections Department of the University of Nevada, Reno, Library (UNRSC), and the Nevada Historical Society (NHS).

We wish to extend our deep appreciation to our mothers, Wilma James and Phyllis Dakins. They remain our most enthusiastic fans. And finally, special thanks go to our son, Reed, who reminds us of our commitment to the discipline of history with his own quest to better understand the past.

INTRODUCTION

Virginia City and the Comstock Mining District yielded enough gold and silver to shake the world, affecting European monetary policy and helping to keep the federal government solvent during the Civil War. The first 1859 strikes signaled the discovery of some of the richest ore ever found, and the miners who followed developed technology that set the industry standard for the next 50 years. The booming success also turned many of the early players into celebrities. Vast riches eluded original claimants James "Old Virginny" Finney and Henry T. "Pancake" Comstock, but they left the imprint of their names on the place. George Hearst bought into the mining district with borrowed money. He left Virginia City after he made his first fortune, parlaying his profits into even greater wealth when he founded a family dynasty.

The 1859 strikes spawned several communities, including Silver City and Gold Hill, but it was Virginia City that emerged as the largest and most famous. Perched on a steep slope more than 6,000 feet above sea level, the location afforded few comforts, but the abundant mineral discoveries below ground made the challenge of living there worth the struggle. As it emerged, Virginia City gained fame for its remarkable combination of vast deposits of gold and silver. Nearly half of its profit came from gold, but silver—though only about a 10th of the value per ounce—was present in such quantities that its bullion became world-famous. Without this discovery, the 1861 birth of the Nevada Territory, carved from the western part of Utah, would not have been possible. Three years later, Comstock successes opened the door for Nevada to join the Union, and since then, it has been known as "the Silver State."

Remarkable mines, including the Ophir, the Gould and Curry, and the Consolidated Virginia, became household names from New York to London, producing dozens of millionaires and a legacy that reverberates into the 21st century. The 1873 discovery of the "Big Bonanza"—a huge mass of nearly solid gold and silver—has been unequaled for its size and concentrated wealth. In all, the mines produced over $300 million during their heyday, a figure that would be counted in the multi-billions 150 years later. The success of these mines inspired exploration throughout Nevada and the Intermountain West, resulting in subsequent discoveries that opened the vast American interior to development and a period of productivity.

Four U.S. senators traced their ascendancy to Comstock wealth, and John Mackay, who always shunned public office, became famous in North America and Europe as perhaps the greatest of the silver barons. At their height in the mid-1870s, the twin communities of Virginia City and Gold Hill boasted nearly 25,000 people. Immigrants from throughout the world, including thousands of Irish, Cornish, Germans, Italians, and Chinese, gave the mining district an international, cosmopolitan stamp. There were also Australians, Moroccans, French Canadians, American Indians, people from the Spanish-speaking world, and African Americans, as well as many others.

A complex, vibrant community included several breweries and foundries, a brickyard, and newspapers that helped define Western journalism. The *Territorial Enterprise* became a legend not only for the respect its reporting earned around the world, but also for the fame one of its

reporters would later gain. Young Samuel Clemens arrived in 1862 and took the name "Mark Twain" the following year. He left in 1864, having learned how to fuse Missouri storytelling with the Western tall tale.

Other notable graduates of the mining district include theater impresario David Belasco—the Bishop of Broadway—who began his career in Virginia City. Richard Jose, one of the nation's first recording stars, was a Comstock orphan singing for handouts. Even the federal General Mining Act of 1872, which continues to regulate the industry in the United States, drew inspiration from disputes between Virginia City mine owners.

In 1869, the Virginia and Truckee Railroad (V&T) linked the Comstock with the transcontinental railroad as it passed through Reno to the northwest. Because of the difference in elevation, the V&T took a circuitous route, turning the equivalent of 37 complete circles on its way down to the Carson River and then to Carson City, where it delivered bullion to the new U.S. Mint in the state capital. The railroad then proceeded north to Reno and eventually south to the farming communities in Carson Valley. The V&T became famous for the millions in ore and bullion it hauled and for the technological achievement its engineered route represented. At the same time, the railroad played a pragmatic role, hauling lumber and other supplies to the mines and transporting ore to mills, all at prices much less than those charged by the earlier teamsters. Riding across its soaring Crown Point Trestle became a must for early tourists to the Comstock, and its engines, the height of 19th-century elegance, became favorites for later Hollywood movies and model railroaders.

Because of its importance, Virginia City and the Comstock Mining District attracted famous—and less well-known—photographers throughout its history. Timothy O'Sullivan (1840–1882) wintered in Virginia City in 1867–1868, a few years after he gained notoriety for his work documenting Civil War battlefields. O'Sullivan was part of Clarence King's famed U.S. Geological Survey of the West, and he took extensive, early photographs of the Comstock Mining District. Renowned Western landscape photographer Carleton Watkins (1829–1916) captured Comstock scenes on two occasions. There were others, some passing through and a few who set up shop in town.

For two decades, Virginia City thrived at a time when profitable mining camps often lasted only a few years. Although its mines began to fail in the 1880s, the town's place in the nation's history was secure. Generations of Comstockers reinvented their home by resuscitating mines with short-term successes and attracting visitors with the allure of the Wild West. Beginning in the 1930s, artists, intellectuals, and aristocratic ne'er-do-wells from the East settled in Virginia City, seeking a fading, romantic vision of the region. The 1940 film *Virginia City* focused new attention on the mining district, and tourists began to arrive in increasing numbers during the two decades following World War II. With the 1959 premier of the television show *Bonanza*, Virginia City became a superstar once again.

The preservation of one of the nation's largest historic landmarks was slow to follow, but eventually the Comstock Historic District emerged as a good example of how to manage derelict buildings and archaeological sites in the Intermountain West. Today Virginia City is home to fewer than 1,000 people, but ghosts of the past continue to stroll along its wooden boardwalks. The town's buildings, cemeteries, and wide-open vistas evoke a time when riches poured from the region's mines and mills.

One

The First Boom
Virginia City Is Born

The 1859 discovery of the Comstock Lode, an immense gold and silver ore body, ended a chapter in mining. For years, Western fortune seekers sought places where little skill and hard work could turn a stream bed filled with bits of gold into wealth and a better life. Throughout the 1850s, California-style placer miners explored the canyon leading from Dayton, the area's first settlement, up to what would be known as the Virginia Range, east of the Sierra. They employed simple technology to process sandy surface deposits for gold dust and an occasional nugget.

A new era of Western mining dawned with the 1859 strikes. The founding of Virginia City established hard rock, underground mining as the industry standard for a new era. The Comstock's excavations featured wage-earning labor, corporate investment, and technological innovation.

Virginia City quickly inspired one of the great "rushes" of the mining West. Thousands arrived to capture some of the wealth. What they found was dramatically different from California's gold country. The Comstock was remote, removed from nearly every resource needed to build a mining town and to sustain life. Most of the lumber, food, and even water would come from somewhere else.

In addition, mining underground and processing ore presented challenges. Engineers developed and tested new technologies to extract and process ore efficiently. The Comstock witnessed the invention of the square-set timbering system and the flat-wire cable, and it saw some of the first, most important underground use of dynamite and pneumatic drills. Millers experimented with heat and compounds to arrive at new approaches for processing chemically bound silver ore. To create an infrastructure far removed from natural resources, the community also had to build roads, a railroad, water systems, and towns. And this was all accomplished in a way that made the expensive endeavor of mining and milling cost-effective. Within a few years, the early Comstockers arrived at an approach to mining in remote regions that influenced development throughout the world for decades.

A lithograph from Dan De Quille's 1876 book, *The Big Bonanza*, captures the moment when Henry Comstock happened upon the 1859 strike of the Comstock Lode. Patrick McLaughlin and Peter O'Reilly found the outcropping, but Comstock was a fast talker and convinced the two prospectors that he had a previous claim. Ultimately, they shared the ore, each selling out within a few months for a fraction of the lode's actual worth. (JAMES.)

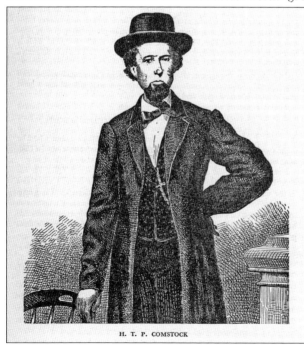

Henry T. "Pancake" Comstock was a local gold miner during the 1850s who lent his name to the lode, or ore body, discovered in 1859. He sold his interest in his Virginia City mine for thousands of dollars, but within a dozen years, he was broke in Montana and committed suicide. This image is from Dan De Quille's 1876 book, *The Big Bonanza*. (JAMES.)

In the spring of 1860, over 100 volunteers traveled north from Virginia City to attack Northern Paiutes and Bannocks at Pyramid Lake. The Native Americans decimated the ragtag army, inspiring Comstockers to prepare for a counterattack that never came. Part of the preparation was this crude stone fort, photographed by Walt Mulcahy in the 1930s, overlooking Silver City from the heights of Devil's Gate. (Mulcahy-CHDC.)

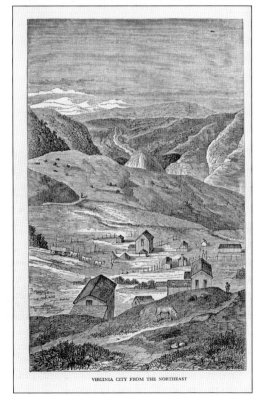

In 1860, Sir Richard Burton, fresh from his exploration of the Nile River, came to the American West. In October, he stopped in Virginia City, and standing at the edge of the Ophir Pit—Virginia City's first glory hole—he drew this image of the emerging community. It was one of the earliest depictions of what would become an American legend. (NSLA.)

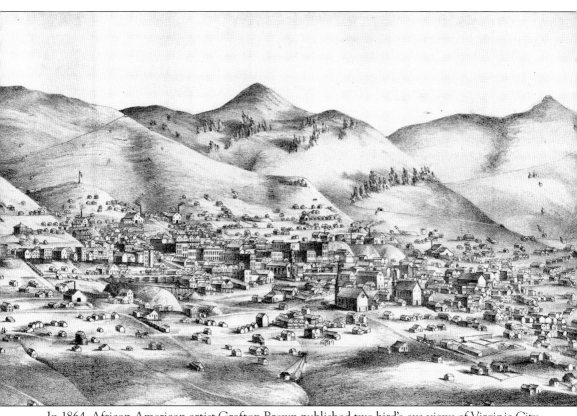

In 1864, African American artist Grafton Brown published two bird's-eye views of Virginia City. The lithographs feature borders decorated with portraits of mining scenes and architectural styles as Virginia City shifted from tent settlement to a permanent community. Brown gives Comstock historians early images of several important mines and businesses. A close up of his portrait of the town shows a metropolis with substantial buildings. (UNRSC.)

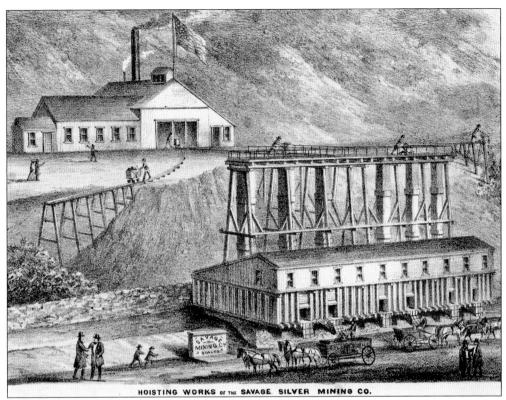

Brown's 1864 bird's-eye view of Virginia City includes early depictions of mining on the Comstock. Within a year of the first strikes, the district had proven itself distinct from the California Gold Country of 1849, because these new miners delved underground. The lithograph shows Savage Mine workers wheeling ore-filled carts. Wagons are loading valuable rock for transport to mills to extract precious minerals. (UNRSC.)

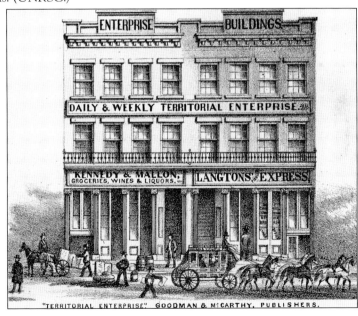

The *Territorial Enterprise*, one of the most famous newspapers of the West, began in Genoa to the south in 1858. It eventually made a permanent move to Virginia City. In 1864, Brown depicted the paper's home as a substantial commercial building. Highly regarded for its expert reporting as well as its occasional spoofs, the *Enterprise* employed Samuel Clemens, who took the name Mark Twain while working there. (UNRSC.)

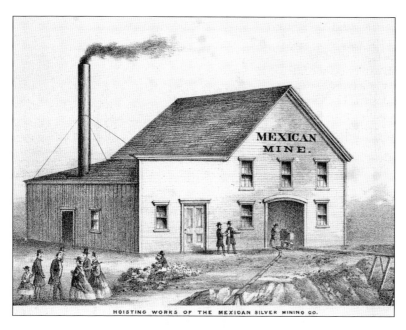

One of Brown's 1864 lithographs includes a depiction of the Mexican Mine, one of the first and more impressive operations in Virginia City. The Maldonado brothers and their Mexican American workers used preindustrial techniques to excavate one of the most profitable early Comstock mines. (UNRSC.)

The Maldonado brothers sold the Mexican Mine in 1863. Most of the profitable ore near the surface had been removed before a photographer captured this image in the mid-1860s. By that time, mine owners were using modern industrial techniques, but without valuable ore, the business was a mere shadow of its earlier success. (LOC.)

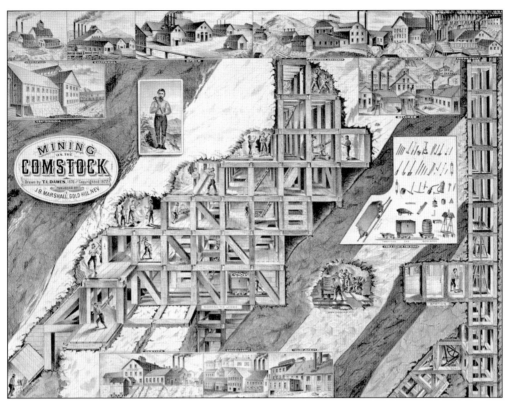

One of the most important early Comstock innovations was square-set timbering, which allowed carpenters to construct a support system to fill any stope—the space that opened when miners removed ore. Philip Deidesheimer, a German-born engineer, invented the approach, which was used internationally for the following five decades. The invention is an excellent example of how Virginia City mines employed techniques that distinguished the district from earlier mining. (LOC.)

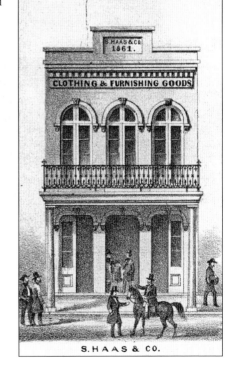

In 1864, Brown depicted a substantial masonry building that dated to 1861. German immigrant S. Haas owned the Clothing and Furnishing Goods store. An ornate iron balcony decorates the second floor of his building. The illustration includes well-dressed gentlemen with top hats. (UNRSC.)

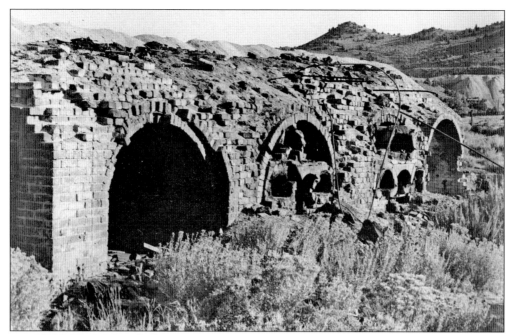

In 1862, entrepreneurs built ovens to produce gas for lighting streets and homes. Mulcahy photographed the remains of these ovens in the 1930s. The use of gas lighting placed Virginia City at the cutting edge of urban living in the nation. Comstockers wanted their communities to be modern places. (Mulcahy-CHDC.)

Original gas tanks, perhaps dating to as early in 1862, were in ruins when Mulcahy photographed them in the 1930s. These tanks probably fell victim to metal scrappers who decimated the Comstock as they gathered materials for the war effort in the 1940s. (Mulcahy-CHDC.)

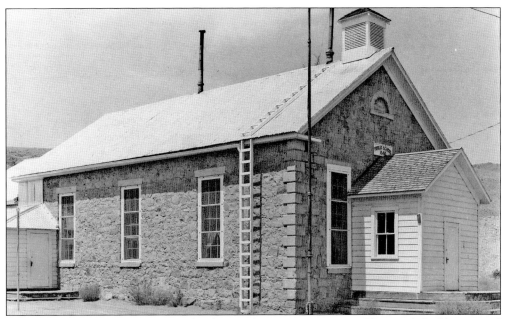

In 1866, Dayton built its grammar school, a sturdy masonry structure. The simple building served for nearly a century and remains as one of the oldest standing schools in Nevada. Dayton was the first of the Comstock communities, with origins as a crude tent settlement in 1850. Mulcahy took this image in 1938. Today the school is a museum and cultural center. (Mulcahy-CHDC.)

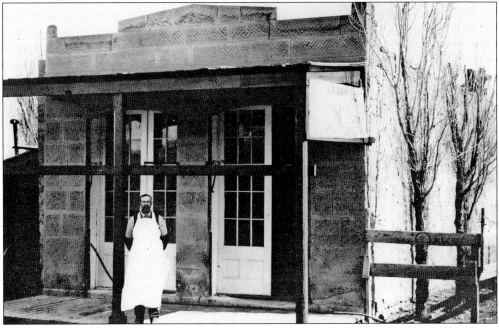

Dayton provided supplies to local placer miners throughout the 1850s. Despite its premier status, the town never acquired the fame of Virginia City to the northwest. Dayton enjoyed its own prosperity, though on a more modest scale. The Dayton Union Butcher Shop, depicted here in the 1870s, was typical of the smaller commercial establishments in the original Comstock community. (CHDC.)

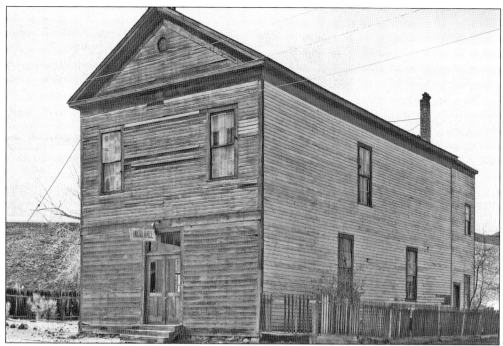

Dayton's United Ancient Order of Druids building was demolished in the 1930s. Dating to the 1860s, the United Ancient Order of Druids, a fraternal organization, provided a social network for new arrivals in young mining communities. The Druids did not have the longevity of the Freemasons or the Independent Order of Odd Fellows, but the group nevertheless made a contribution to local society. (Mulcahy-CHDC.)

The Leslie Hay Barn on Dayton's Pike Street is often associated with camels imported to the area to transport materials across the deserts of Nevada. The experiment with camels mostly failed, but the presence of the exotic beast lingers in local folklore. This structure probably never housed camels, but it does serve as an example of the permanent, sturdy architecture that blossomed in Dayton during its earliest development. (Mulcahy-CHDC.)

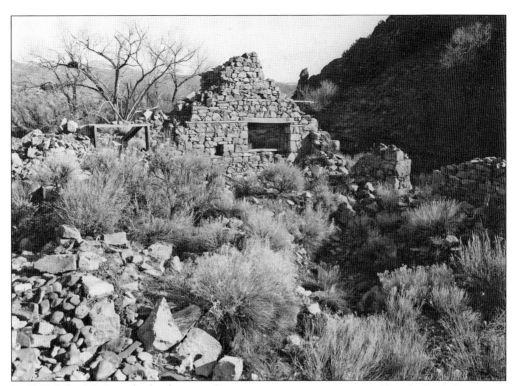

In 1862, John McCone built what was perhaps the first foundry in Nevada. His structure stood along the Gold Creek, which flowed south from Gold Hill to Dayton and the Carson River. Much of the iron work for the Comstock mines and buildings was forged locally by one of the Comstock's many foundries. Mulcahy photographed these ruins in 1938. (Mulcahy-CHDC.)

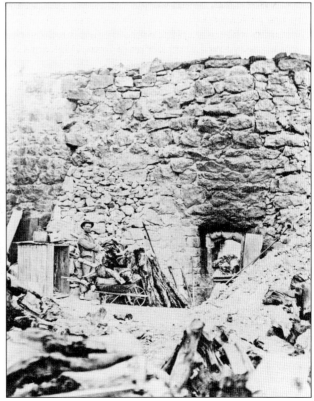

As the Comstock Mining District grew in population and wealth, it developed a voracious appetite for natural resources, affecting forests in the Sierra Nevada, dozens of miles to the west and northwest. This image shows a worker burning wood by the cord as he roasts limestone to produce lime for mortar during Virginia City's heyday. These ovens were south of Dayton. (CHDC.)

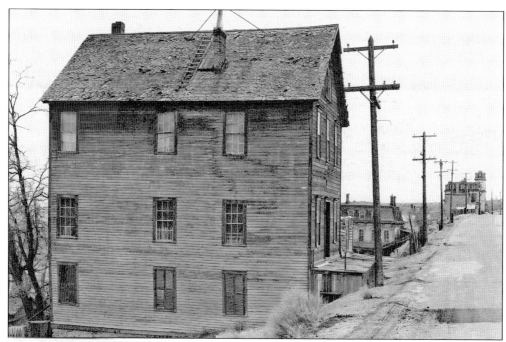

This three-story apartment building, now known as the Nevin house, stood in a rough area that emerged with the growth of Virginia City. The Barbary Coast consisted of several blocks, a disreputable stretch of South C Street. Still those living in these apartments may have been respectable, since people of diverse backgrounds and economic standing resided close to one another in the tightly packed community. (Mulcahy-CHDC.)

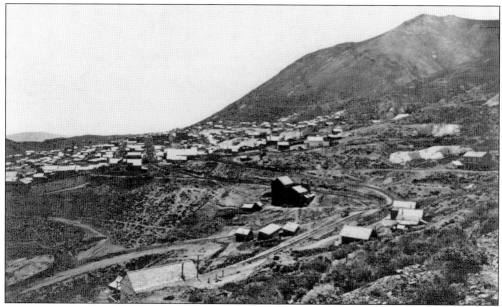

When famed Civil War photographer Timothy O'Sullivan visited the Comstock in 1867, he found communities that, while still young, were well-established and prosperous. Virginia City, viewed from Cedar Hill to the north, sprawls down the slope of Mount Davidson. The road in the foreground leads to the Truckee Meadows and the river crossing where Reno would emerge. (LOC.)

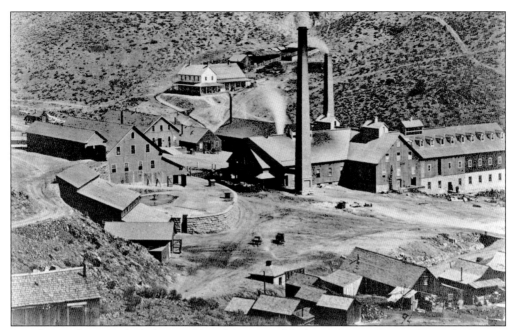

O'Sullivan photographed the Gould and Curry Mill below Virginia City in Six Mile Canyon in 1867. The facility was state-of-the-art and finely appointed. During the 1860s, the Gould and Curry Mine sent millions of dollars' worth of ore to its mill for processing. Only scarce remnants survive indicating the existence of the mighty complex. (LOC.)

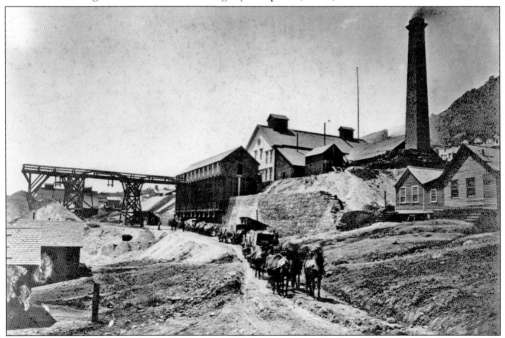

A team of horses hauls an ore wagon to a mill while another wagon waits to be filled at the Savage Mine in this 1867 O'Sullivan photograph. The mine, at the south end of Virginia City, had a large chimney belching smoke from a steam engine that pumped water from the depths while also lifting and lowering cages full of miners and ore carts. (LOC.)

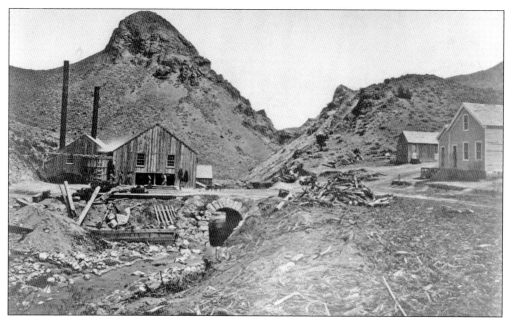

O'Sullivan captured this image of Six Mile Canyon and Sugarloaf Mountain to the east of Virginia City. Following the same pattern used in Gold Canyon, prospectors ascended Six Mile Canyon in the late 1850s, ultimately discovering the north end of the Comstock Lode. By 1867, simple, functional buildings stood scattered along the road that led to Dayton and the Carson River. (LOC.)

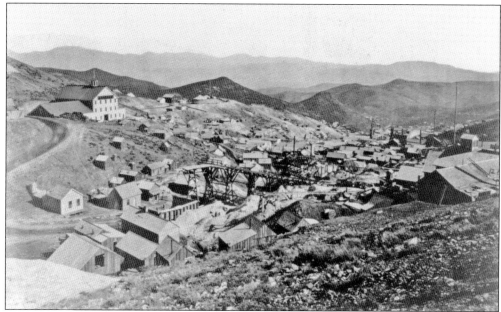

Gold Hill, Virginia City's sibling to the south, was also a well-developed industrial town when O'Sullivan documented its splendor in 1867. The winding road to the left was called Greiner's Bend after the toll road operator. Gold Hill was tightly packed, hemmed in by the surrounding hills. It was home to thousands of workers and wealthy mines, with names such as the Crown Point, the Yellow Jacket, and the Kentuck—legends in industrial history. (LOC.)

Two

THE TOWNS
THRIVING COMMUNITIES
WELCOME THE WORLD

Within a few months of the first strikes, hundreds arrived and began building towns along the north-south axis of the Comstock Lode. By the spring of 1860, thousands of fortune seekers followed. As word of wealth spread, the number of international immigrants increased until Nevada could claim more foreign-born per capita than any state in the nation. While Dayton had roots that reached into the earliest part of the 1850s, Virginia City, Gold Hill, and Silver City followed the discovery of underground deposits and were all founded in 1859.

Virginia City emerged as the center for wealth and culture. With the largest population, it attracted the finest stores and architecture, and it had the most diverse population, ranging from a large Chinatown to thousands of Irish immigrants, 1,000 Cornish miners, and several hundred Germans.

Gold Hill was not able to compete with its northern neighbor. It thrived as a working-class community, providing a home to laborers who worked in the local mines. Farther south and across the line that separated Storey and Lyon Counties, Silver City remained small and humble. Removed from the commercial might of Virginia City, Silver City was able to develop its own character. For example, the generally pro-Union Comstock accused Silver City of harboring Southern sympathies during the Civil War. The truth of that assertion is as elusive as the more modern declaration that the town of 160 now has more advanced degrees per capita than any other community in the nation.

In all, the various Comstock settlements claimed their own identities, independent of other, distant urban centers. Salt Lake City, 500 miles to the east, was supposed to provide governmental leadership, but finding little in that regard, the mining district became the core of the new Nevada Territory after March 1861. Culturally, the Comstock always looked west to the cities of Northern California. But they, too, were distant, leaving their Nevada neighbors to find their own way.

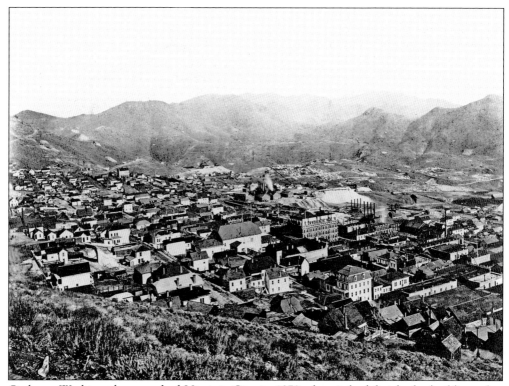

Carleton Watkins photographed Virginia City in 1878 when it had finished rebuilding after the Great Fire of 1875. This image looks from the west towards the northeast. The six-story International Hotel dominates the center of town. To the left is the large but plain south wall of Piper's Opera House. With the mines producing millions every month, Virginia City was at its height, with as many as 15,000 people tightly packed on the hillside.

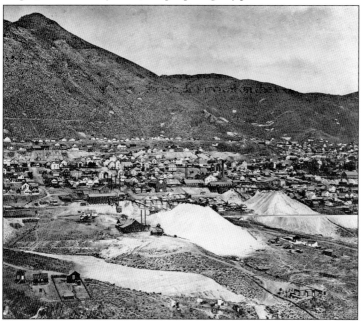

Another Watkins image, this one captured from the east, shows Mount Davidson rising above Virginia City. Huge mine dumps—the white waste rock from underground excavations—dominate the lower reaches of the south end of the community. (CHDC.)

James H. Crockwell captured this image of the International Hotel in 1890. Standing in the center of town, it was Virginia City's most impressive business structure. The Second Empire–style building soared six stories after the 1875 fire. It boasted the first commercial elevator in Nevada and luxurious rooms, one of which served as home to Bonanza King John Mackay. Businesses operated from fronts facing C and B Streets. The building burned in 1914. (LOC.)

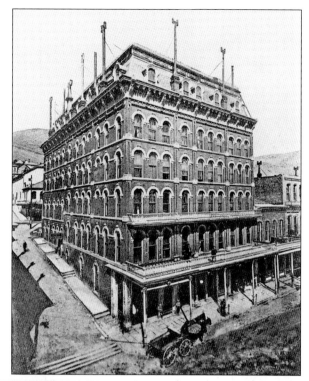

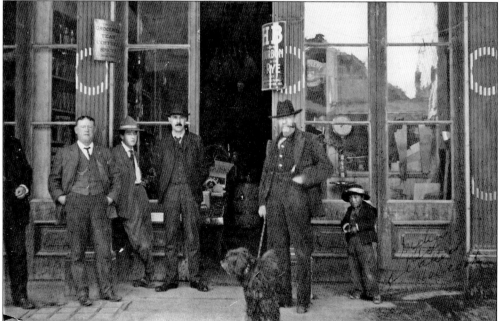

Virginia City developed a vibrant commercial corridor within months of its 1859 founding. This image of Hearer's Grocery Store documents a typical business in the 1870s or 1880s. Famous for mining, the district nevertheless supported hundreds of businesses, and many residents acquired wealth with hard work above ground. Writing on the photograph identifies the Native American child as "Hancock."

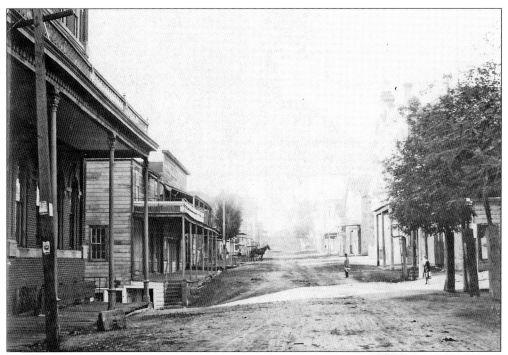

This is one of two views of B Street, taken around 1885. Here the photographer was looking south. Trees grow to the right in front of Piper's Opera House, and a child stands on Union Street. The hall for the Independent Order of Odd Fellows, a fraternal organization, dominates the left foreground. Virginia City had a combination of masonry and wooden buildings, and many streets were lined with boardwalks.

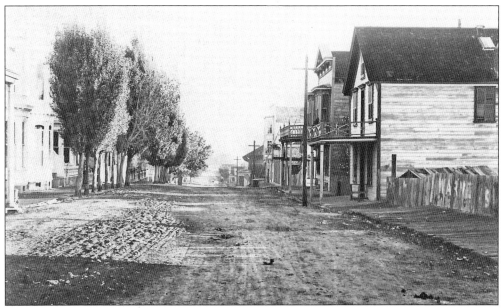

The second view of B Street, this one with the camera facing north, provides a vivid image of how dirt streets could turn into muddy messes. With trees in bloom and given the angle of the morning sun, it is likely the photographer took this picture in spring.

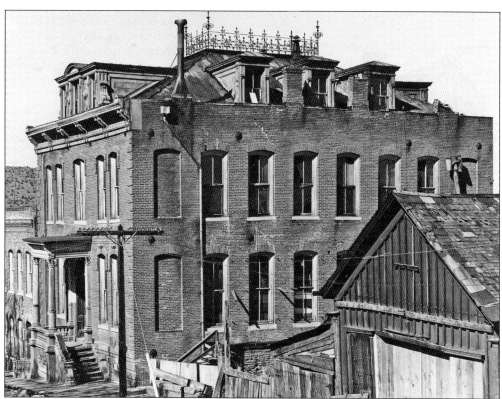

The Marye Building, owned by stockbroker George Marye, boasted one of the more impressive facades on B Street. It was typical of the substantial and ornate development that dominated the center of Virginia City. Marye's son went on to become ambassador to Russia just before the 1917 revolution. Mulcahy took this photograph shortly before a massive fire destroyed the structure on June 15, 1950. (Mulcahy-CHDC.)

The front door of the Marye Building exhibited ornate Corinthian columns supporting an equally elaborate portico. The structure exuded permanence, and yet it failed to survive. (Mulcahy-CHDC.)

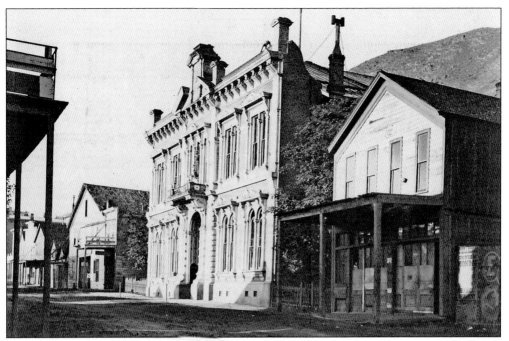

Storey County opened its new courthouse in 1877 after its predecessor burned in the 1875 fire. Costing $117,000, it was the most expensive county courthouse built in Nevada during its first half century. Kenitzer and Raun of San Francisco designed the public facility, which continues to house most of the county offices in Virginia City. The structure dominated B Street, a busy thoroughfare packed with two-story commercial and residential buildings.

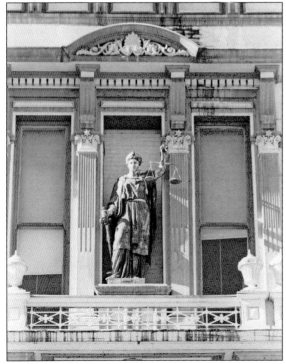

A statue of Justice graces the front of the Storey County Courthouse. Locals claim she is one of two or three in the nation without a blindfold. There are, in fact, over two dozen similar statues scattered throughout other states. Justice was originally gilded, but by the time Mulcahy took this picture in the 1940s, county workers had painted her peeling facade, giving her a maroon robe and silver skin. (Mulcahy-CHDC.)

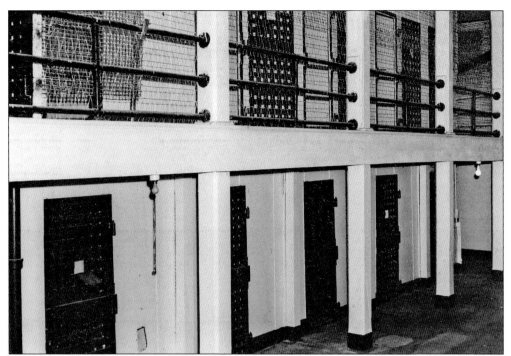

The Storey County Courthouse included a state-of-the art jail. It was originally designed to house men on the lower floor and women on the upper, but more men were usually arrested, causing the second tier to be used by both genders. The facility served the county until the 1980s, when federal regulations prohibited its use for incarceration because it lacked a toilet in each cell. (Mulcahy-CHDC.)

This apartment house on B Street was built near the courthouse after the 1875 fire. Locals referred to the structure as the "white house," a nod to a different place where Mark Twain once lived. Recent paint analysis indicated this structure was actually blue. Three stories of apartments meant for close living for dozens of residents, which was typical for Virginia City. The restored structure still serves as an apartment building. (Mulcahy-CHDC.)

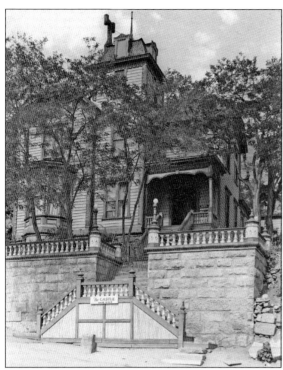

The Graves mansion, constructed before the 1875 fire, was far enough south on B Street to survive the conflagration. Robert Graves built the structure, which became known as the "Castle"—a turreted, Second Empire dwelling perched high on a bluff overlooking Virginia City. It was situated along "millionaire's row," and 20th-century owners marketed the place as a house museum, complete with original furnishings and appointments. (Mulcahy-CHDC.)

The Graves carriage house was the ultimate expression of wealth. Most people in Virginia City could not afford a horse because of the cost of stabling the animal. Virginia City was a tightly packed urban area, and most people walked to work, stores, and restaurants. To own a horse and carriage required a great deal of money, and Robert Graves displayed his success with this ornate structure. (Mulcahy-CHDC.)

Robert Graves was the successful superintendent of the Empire Mine who built the Castle in Virginia City. After striking it rich, most Comstock millionaires constructed elaborate mansions in California's Bay Area. Many retained distinguished but relatively modest homes in Virginia City in order to manage their business affairs on-site. Graves was typical of the midrange, successful people who turned opportunity into wealth. (CHDC.)

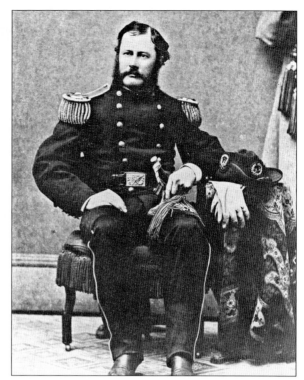

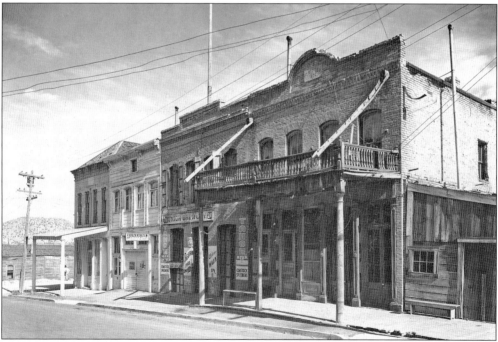

By the 1930s or 1940s, when Mulcahy photographed this North C Street business block, it had seen better days. On the right is the brick, two-story Ritter Building dating to 1876. To the left is the Union Brewery, so named because the saloon operator served beer on tap. For two decades beginning in the 1860s, C Street was home to a bustling commercial corridor. (Mulcahy-CHDC.)

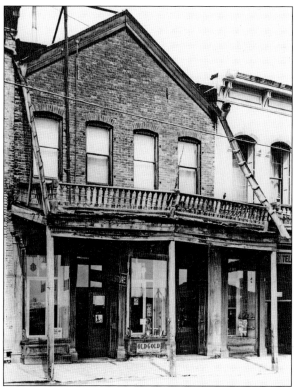

Pioneer Drug Store, once a cornerstone of Virginia City commerce, had dwindled by the 1940s. Still, the C Street, two-story brick building projected the strength and permanence that dominated construction during the Comstock's heyday. (Mulcahy-CHDC.)

Three structures stand wall-to-wall on the north side of Taylor Street between A and B Streets. Although they may have served single families, it is more likely the owners rented rooms. The community was so tightly packed that every piece of real estate was subject to development. While most buildings faced downhill or uphill, some like these clung to the slope of east-west streets. (Mulcahy-CHDC.)

The Panelli Building was one of many imposing commercial structures dating to the height of Virginia City in the 1870s. The building eventually served as home to Ford's Mercantile Store. In the 20th century, it fell on hard times and was demolished. (Mulcahy-CHDC.)

Virginia City's red-light district along D Street was actually the center of entertainment during the 1860s and 1870s. City ordinance restricted prostitution to an area that also boasted fine theaters, restaurants, and saloons. After the dawn of the 20th century, the district declined, and by the late 1940s, illicit businesses along D Street had closed.

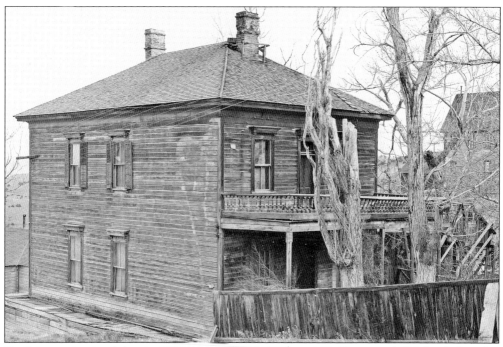

Tradition maintained that in 1873, miners found the famed Big Bonanza 1,600 feet below this structure on the corner of Union and F Streets, three blocks below the commercial corridor. Thousands of Virginia City residents lived in apartment buildings, but many families preferred individual homes, of which there were hundreds. This structure could have served in either capacity. (Mulcahy-CHDC.)

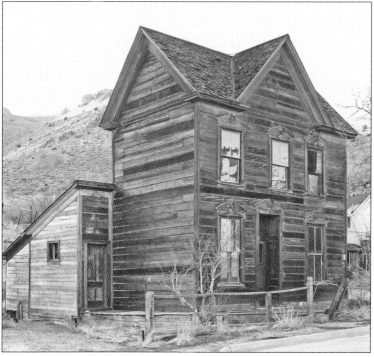

A dilapidated two-story house on C Street seemed well beyond the hope of preservation when Mulcahy took this picture, perhaps as late as the 1950s. In a heroic effort, the structure was restored at the end of the 20th century. Like so many residential buildings, it is not possible to determine whether rooms were rented on occasion, but that is a pattern common in the census records. (Mulcahy-CHDC.)

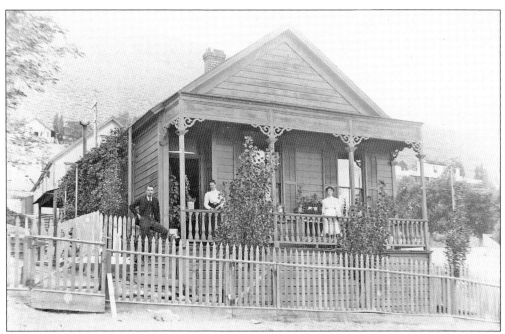

A more humble abode is an example of what most people would have owned in the first decades of Virginia City's settlement. Houses of this sort usually had a hall running the length of the structure, opening to a parlor, bedrooms, and then a kitchen, with a privy in the back. A family proudly poses for their photograph in front of their home in this undated photograph.

Housing ran the spectrum from humble, shared, one-room apartments to luxurious houses above the C Street commercial corridor. The King mansion, on A Street, was built after the Great Fire of 1875. It survives today as one of the more substantial homes erected by the affluent of Virginia City. George King was a banker and a director of the Virginia and Truckee Railroad. (SHPO.)

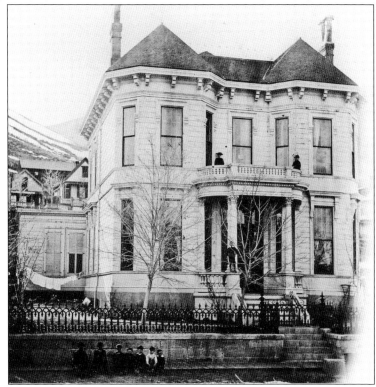

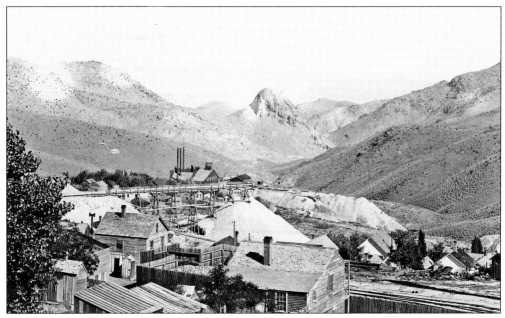

While Virginia City was a crowded, bustling community with businesses and homes, it was also the setting for some of the world's greatest mining operations. This image from roughly 1880 looking east shows houses in the foreground and massive mine dumps farther down the hill. People built lives in the midst of cutting-edge technology and a 24-hour cycle of subsurface detonations and the rumbling of mills.

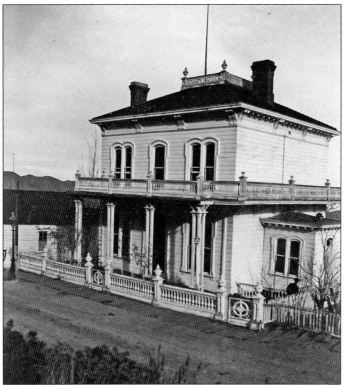

James Fair was one of the legendary Bonanza Kings, a success story that far exceeded that of an average mine superintendent. With the 1873 discovery of the Big Bonanza, Fair, together with his partners including John Mackay, became one of the wealthiest men in the world. Fair went on to purchase a seat in the U.S. Senate, and he built this fine mansion in Virginia City. It was later moved to the Truckee Meadows, where it burned.

Theresa Fair, the long-suffering wife of James Fair, enjoyed the benefits of Comstock wealth but was faced with the infidelities and disagreeable character of her husband. Ultimately, their marriage ended in divorce in 1883. Theresa was as admired for her generosity as her husband was despised for his self-serving, mean-spirited approach to life.

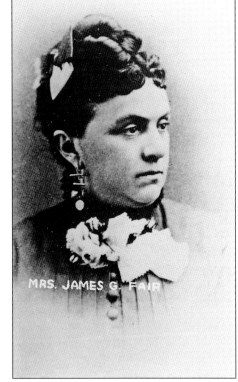

Virginia City was known for its wealth, but Gold Hill had its own prestige. Crown Point Mine superintendent John P. Jones lived in this Gold Hill house when he made millions. He went on to serve Nevada as a U.S. senator (1873–1903), taking a venomous stand against Chinese immigration and working hard to buoy the price of silver. (Mulcahy-CHDC.)

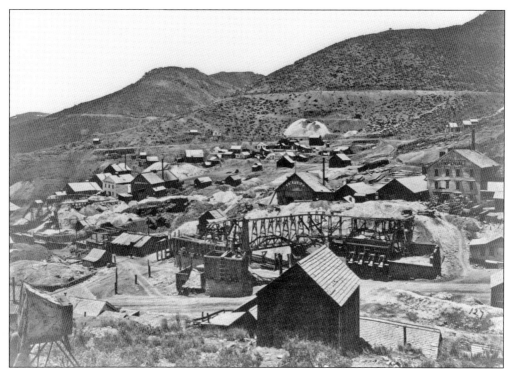
Timothy O'Sullivan took this photograph of Gold Hill during his 1867–1868 visit to the Comstock. A mine dump sprawled in front of the Imperial and Empire Mines, and an elaborate trestle allowed miners to roll carts to dump gold- and silver-laden rock into ore bins. O'Sullivan was standing on the summit known as Fort Homestead. (LOC.)

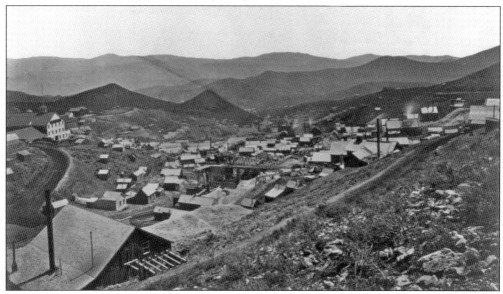
Another O'Sullivan image of Gold Hill, looking southeast, shows a growing, sprawling community. Gold Hill's mines were at the height of their prosperity during the 1860s, producing a vibrant town. The winding switchback at the left, known as Greiner's Bend, connected Gold Hill to Virginia City. (LOC.)

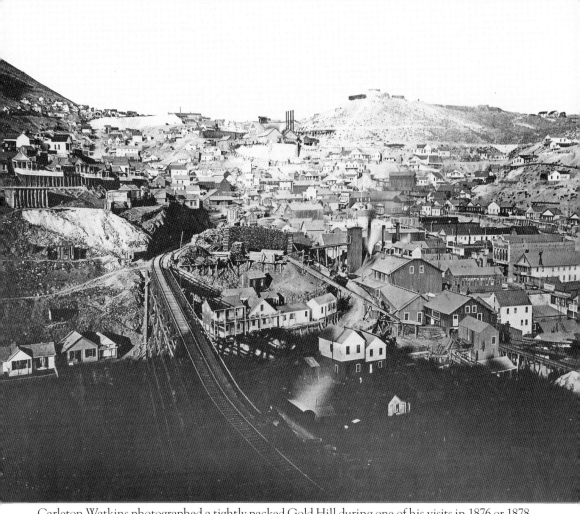

Carleton Watkins photographed a tightly packed Gold Hill during one of his visits in 1876 or 1878. The surrounding hills hemmed in mines, homes, and commercial businesses in a community that had reached roughly 8,000 people. The Crown Point Trestle—the wooden structure extending from the foreground—soared high above the ravine below and was a favorite for 19th-century tourists visiting the Comstock.

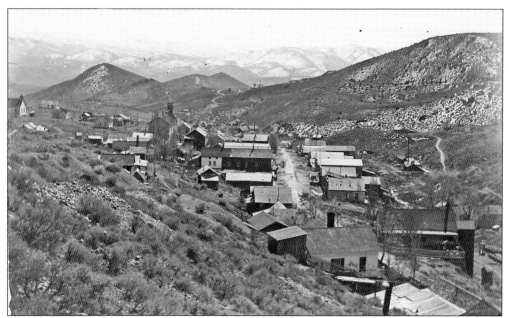

Silver City, pictured in this undated photograph, was one of the original Comstock communities founded in 1859, but its mines worked a weak spur of the lode. As a result, the community never prospered like its northern neighbors.

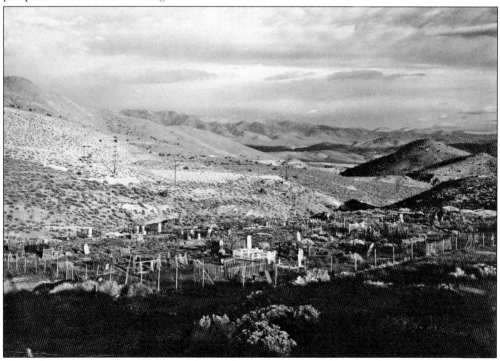

The Silver City cemetery preserves the tombstone for one of the Grosch brothers, prospectors credited with discovering the importance of local silver deposits long before anyone else. Mulcahy captured this image in the 1930s, when the population of the community had declined to less than 100 from a high of around 1,000. (Mulcahy-CHDC.)

Three

BUILDING THE PLACE
MAKING THE COMSTOCK LIVABLE

Because the Comstock Lode was inside a dry, barren mountainside far removed from other urban centers, everything from food and water to lumber, iron, and equipment had to be brought in from somewhere else. First of all, this meant entrepreneurs had to cut roads so supplies could arrive. Eventually, the isolation of Virginia City also required the engineering and building of a route for a railroad.

The Comstock drew on a vast network to acquire the essentials needed to build an industrial giant but also simply to survive. Enormous tracts of Sierra forests were denuded for lumber. Nearby fish and game were depleted, but the mining district also exploited an international marketplace for everything a hungry community could want. Oysters from the Chesapeake Bay, Scottish ale, and German mineral water were available in abundance. Seamstresses and dressmakers re-created the latest Parisian fashions, and a thriving Chinatown imported an entire way of life so its residents could imagine they had never left the Asian shore.

The Comstock had many other things needed to make it a home. Churches and fraternal organizations provided a sense of community for new arrivals. Local newspapers brought word of distant events and reported on the latest news from within the mining district. Theaters booked the finest talent the world knew. Regional breweries did their part, as did local foundries, each addressing needs in their own ways. At the same time, workers formed unions, volunteers organized firefighting brigades, and others put together military units, baseball teams, and bands. And there was always time for a parade.

Besides the mining, the Comstock also gained international fame for its remarkable engineering works. A system of pipes and flumes that brought water from the Lake Tahoe Basin and the vast network of roads and rail lines exceeded what most imagined possible. Ultimately, Virginia City and the Comstock proved to the world that it was possible to build a home anywhere, no matter how remote and desolate.

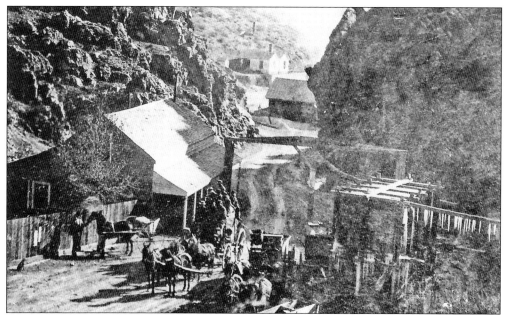

The Toll House at Devil's Gate, just north of Silver City, was a busy place. The first Comstock road is depicted here in a crude 1866 photograph. It extended from Dayton, along Gold Canyon, to Gold Hill and Virginia City. Roads were generally private enterprises, and operators charged travelers to recoup costs and make a profit.

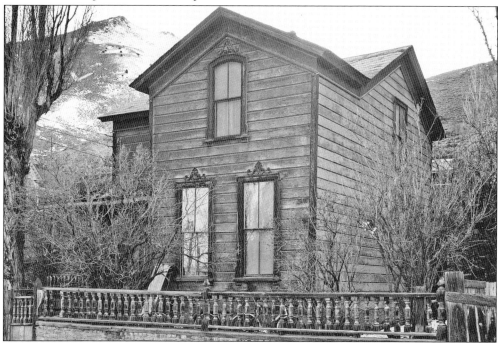

In the mid-20th century, Mulcahy identified this as the home of Dr. D. M. Geiger, who financed the profitable road from Virginia City north to the Truckee Meadows. The toll road opened in 1863 and serves today, with modifications, as the main route from Reno to the Comstock. (Mulcahy-CHDC.)

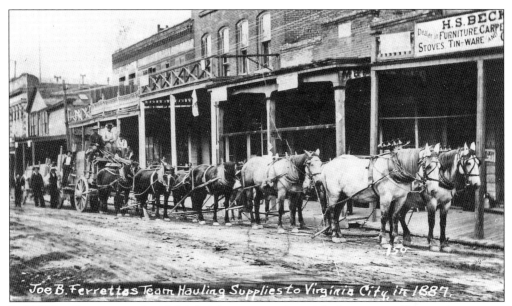

Joe B. Ferretta's Team Hauling Supplies to Virginia City in 1887.

In 1887, Joe Ferretta posed with his freight wagon and an eight-horse team. Comstock teamsters lost a great deal of their trade with the arrival of the railroad in 1869, but there was still sufficient business to keep dozens of them employed for the following years.

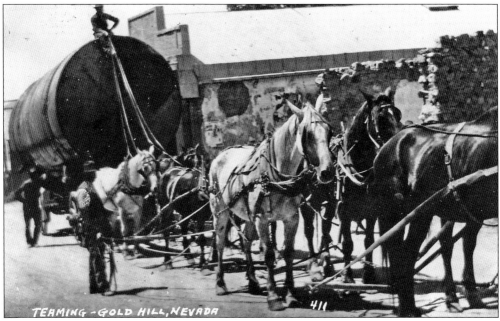

TEAMING – GOLD HILL, NEVADA

A teamster stopped for a 19th-century photographer while he was hauling a large piece of equipment in Gold Hill. He was probably taking it from a foundry to a mine or mill. Because the Comstock was a center of industry, it manufactured much of what it needed. Then teamsters and their sturdy horses were called upon to deliver the product.

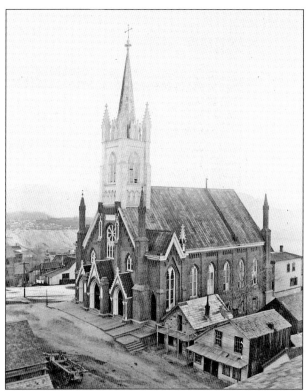

St. Mary in the Mountains Catholic Church rests on a foundation that dates to 1868, but the upper structure was destroyed in the 1875 fire and rebuilt shortly afterward. The imposing edifice, depicted here around 1880, was a spiritual home to an enormous Irish American population and to others as well. Fr. Patrick Manogue, a future archbishop, supervised the church's construction. It is the largest church in Virginia City and continues to serve more people than any other place of worship in town.

The Daughters of Charity of St. Vincent de Paul arrived in Virginia City in 1864. They quickly established a school and the community's orphanage, shown here around 1875. At its height, the institution housed over 100 orphans, and many other families paid to have their children attend the school. In 1876, the Daughters of Charity opened a hospital, the best medical facility in town. They left Virginia City in 1897.

St. Paul's Episcopal Church stands on F Street just to the northeast of the Catholic church. The Episcopalians were fewer in number and could not afford an extravagant edifice. Instead, their building was a humble wooden structure with elegant design. The Gothic Revival church occasionally opens for services. This photograph dates to the mid-20th century.

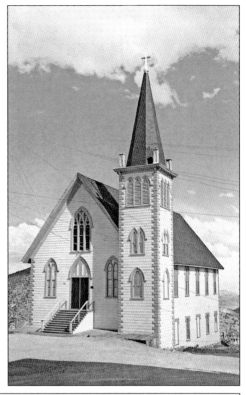

First Presbyterian Church is the oldest standing religious structure in Virginia City because it was outside the 1875 fire zone. Built in 1867, it became little more than a ruin by the mid-20th century. A limited congregation had dwindled and could not afford the upkeep of the building. Miraculously, the building survived, and local Presbyterians restored the church, which now holds weekly services. (Mulcahy-CHDC.)

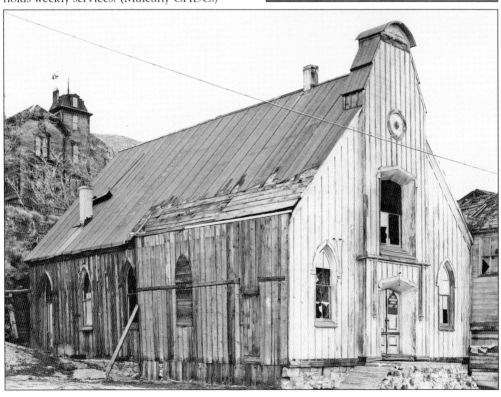

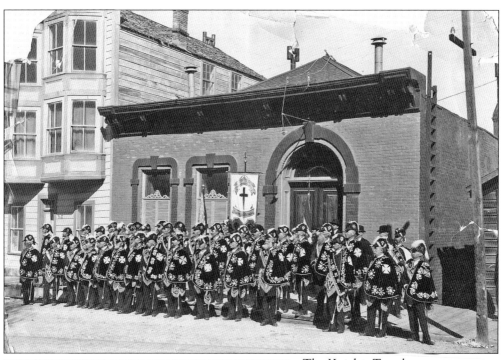

The Knights Templar, an organization within the Free and Accepted Masons, posed behind the Masonic Lodge about 1880. Uniforms featured embroidery with silver thread. The Masons were politically powerful on the Comstock. Their lodge no longer stands.

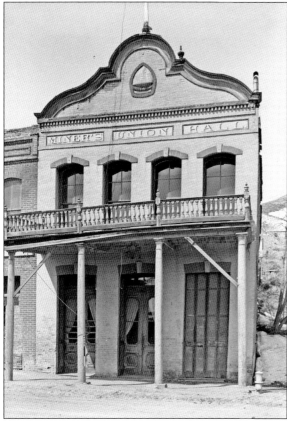

Robert W. Kerrigan took this picture of the Virginia City Miner's Union Hall in 1937. The Comstock boasted the first miner's union—dating to 1863—organized west of the Mississippi. By the late 1860s, it became virtually impossible to be elected to public office without a union endorsement. Besides fighting for worker's rights, wages, and safety, the Miner's Union also had one of Nevada's earliest public libraries. (LOC.)

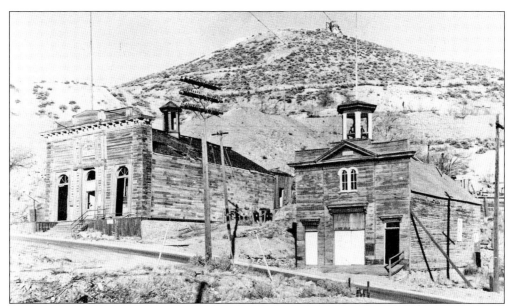

By the 1930s, the Gold Hill Miner's Union Hall (left) and the fire house (right) were in need of repair. Gold Hill, with its large population of miners, was known for its strong support of union activity. Neither structure survived to the end of the 20th century. (Mulcahy-CHDC.)

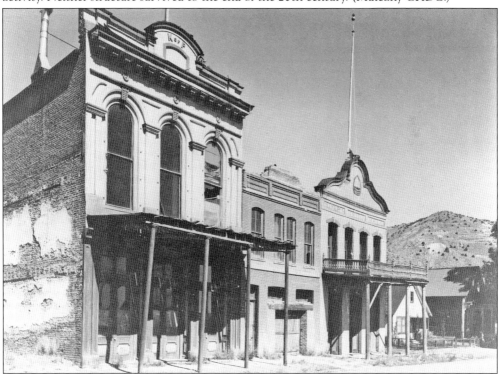

The Virginia City Knights of Pythias Hall (left) and the Miner's Union Hall (right) frame a smaller building. The Pythians were part of a fraternal organization organized during the Civil War. It was a popular alternative to Freemasonry in the 19th century, but its numbers have dwindled in recent years. (Mulcahy-CHDC.)

Attorney and Comstock resident William Woodburn served three terms in Congress in the 1870s and 1880s. The Irish immigrant drew on the strength of the Miner's Union, but he also had an affiliation with the local Fenians, Irish revolutionaries who formed the backbone of the Nevada National Guard. An association with fraternal organizations, labor unions, and ethnic groups was essential for a successful political career. (LOC.)

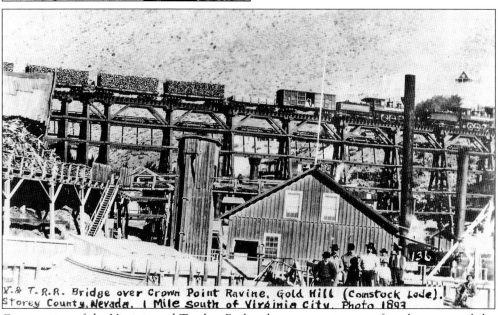

Construction of the Virginia and Truckee Railroad was an engineering feat that captured the nation's attention. Building a railroad that would ascend a mountain required expert survey work, several tunnels, and hard labor. The Crown Point Trestle was needed to cross a ravine in Gold Hill. It came to symbolize what the giants of the Comstock could achieve. This photograph dates to 1893.

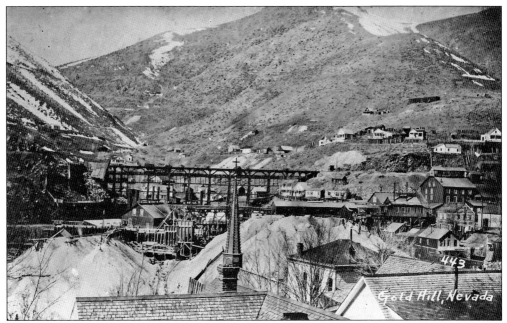

A photograph of Gold Hill dating to the 1870s or 1880s shows the Crown Point Trestle in the background. The spire of St. Patrick's Catholic Church rises in the foreground. The V&T Railroad provided a constant backdrop for those living on the Comstock. Gold Hill was dominated by immigrants from Cornwall, a county in England, while nearly one-third of Virginia City was Irish.

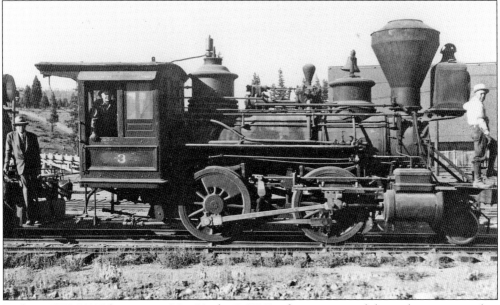

Built in 1875, V&T locomotive No. 21, the *J. W. Bowker*, was one of the earliest engines that served the railroad for decades. Many ended up appearing in Hollywood films—the *Bowker* starred in the 1939 Cecil B. DeMille classic *Union Pacific* and was renamed "Jupiter" for the 1999 film *Wild, Wild West*. This photograph shows the engine in its final days of active use during the early 20th century. (CHDC.)

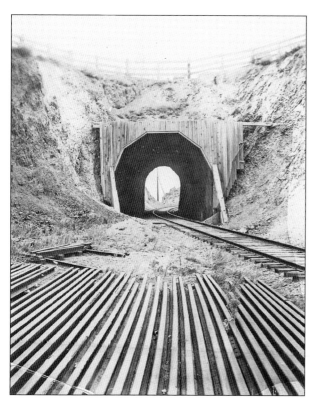

A tunnel between Virginia City and Gold Hill at an area known as the Divide shows the sort of construction common on the V&T. Rails, stored for further work, appear in the foreground of this undated photograph. Most V&T tunnels were much longer. Today the road known as the truck route passes over this tunnel, which is changed but still serves the railroad.

A longer tunnel on the V&T line between Virginia City and Carson City had a tin ceiling clothing a wooden skeleton. This prevented rocks from falling on passing cars. Iron scrappers removed the rails during World War II. Further salvage work extracted the wooden upright timbers, causing the metal ceiling to crash to the floor. (Mulcahy-CHDC.)

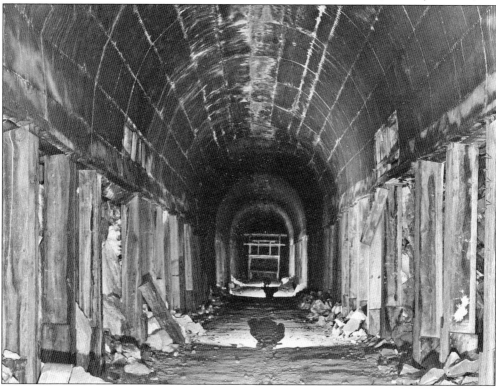

The frame of the tunnel leading from underneath St. Mary in the Mountains to Virginia City's rail yard extends from the center to the left in this early-20th-century photograph. D Street is in the foreground, and the Catholic and Episcopal churches are in the background. (Mulcahy-CHDC.)

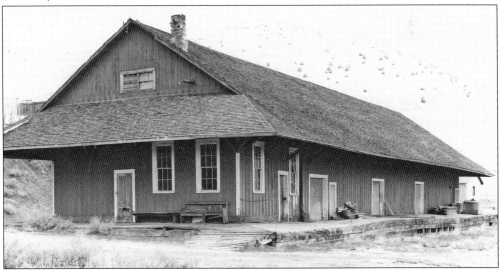

The V&T freight barn appears in this Mulcahy image that dates to around 1950. The railroad lowered the cost of the delivery of supplies to the Comstock and ore to the mills. The V&T extended the life of the mining district by providing inexpensive transportation of ore. That meant mines could send rock with less gold and silver to the mills and still make a profit. (Mulcahy-CHDC.)

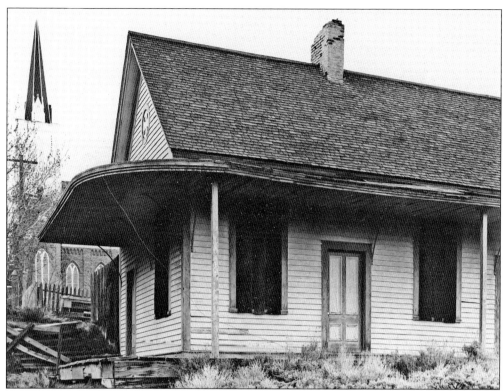

The first passenger depot in Virginia City was south of St. Mary in the Mountains. It served the community while workers excavated the final tunnel at the base of the church to extend the line north to the rail yard in the center of town. (Mulcahy-CHDC.)

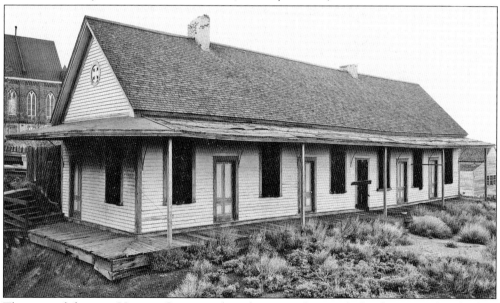

The original depot in Virginia City ceased to play a significant role for the V&T after the line extended into the center of town. It subsequently performed other functions, at times becoming a home. (Mulcahy-CHDC.)

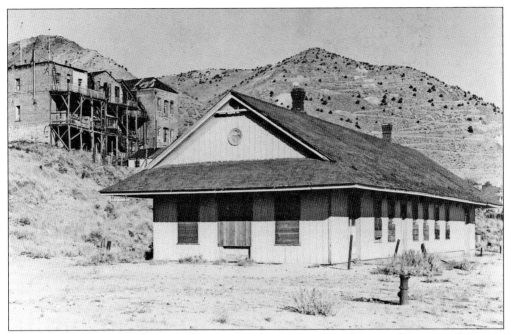

By the 1950s, when Mulcahy took this photograph, the passenger depot in the center of Virginia City's rail yard was seeing its final days. The building was the terminus after the railroad extended its line along a tunnel in front of St. Mary in the Mountains Catholic Church. At its height, the railroad delivered 50 trains to the Comstock every day.

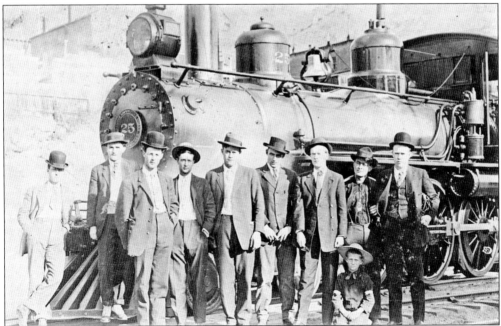

An early-20th-century baseball team stands in front of Engine No. 25, one of the last locomotives the V&T purchased. The unnamed No. 25 lacked the grace and elegance of its earlier counterparts, but it was a workhorse that served the railroad for several decades. Today it still operates at the Nevada State Railroad Museum in Carson City, Nevada.

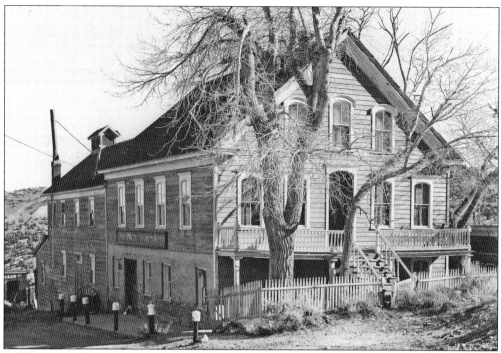
Building an infrastructure in Virginia City included having places to spend some relaxing hours and having fresh beer to drink. The Nevada Brewery was a cornerstone for the community, supplying a quality beverage for decades. The structure later served as an artist's studio, a yoga center, and a Hindu monastery before it succumbed to fire in 1983. Mulcahy captured this image in the late 1930s. (Mulcahy-CHDC.)

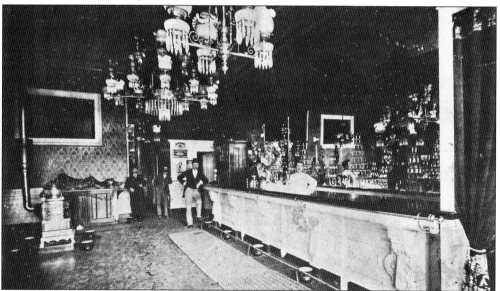
The Crystal Bar was a favorite "two-bit" saloon in Virginia City, pictured here in 1889. Unlike a "one-bit" establishment, customers at the Crystal paid 25¢ for a beer, a whiskey, or a cigar. An exclusive private establishment upstairs was known as the Washoe Club, which allowed admittance only with paid membership. The Crystal was famous for its fine chandeliers.

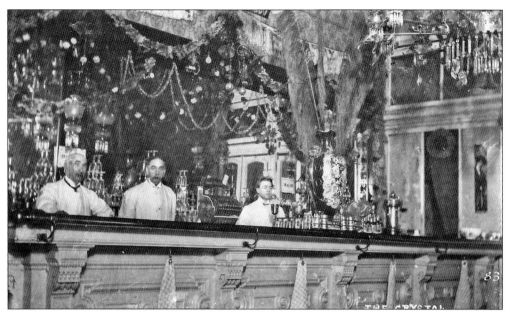

Three bartenders appear in this 19th-century image of Virginia City's Crystal Bar. In the 20th century, the business moved a block north. Its former home became known as the Washoe Club, taking the name of the private club upstairs. The Washoe Club continues to function as a saloon. The Crystal Bar now serves as the offices of the Virginia City Convention and Tourism Authority.

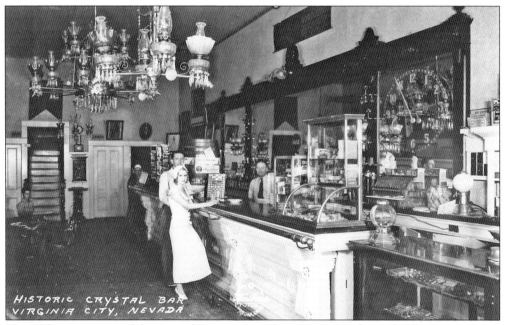

The 20th-century site of the Crystal Bar stood on the corner of Taylor and C Streets. A stylish woman is probably enjoying a mint julep, the signature beverage at the Crystal. When the business moved a block north of its 19th-century location, it took the celebrated crystal chandeliers to its new home.

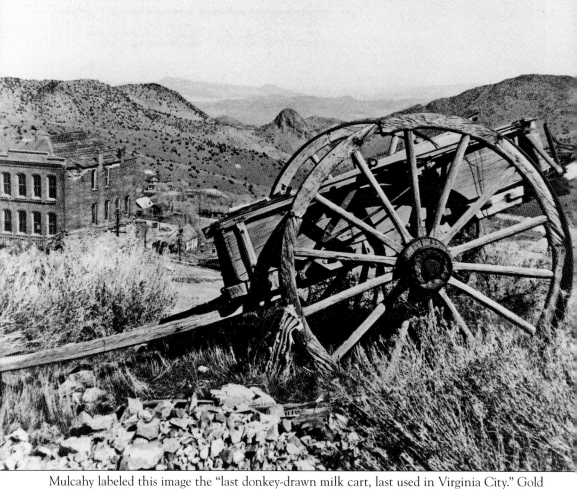

Mulcahy labeled this image the "last donkey-drawn milk cart, last used in Virginia City." Gold and silver mining was glamorous and made international headlines. The delivery of milk, like so much of what was necessary for simple survival on the Comstock, was essential but less sensational. (Mulcahy-CHDC.)

The Virginia City Wood and Coal Office dates to after the 1875 fire. Gold and silver mining capture the imagination, but staying warm in the winter presented a very real challenge for thousands of residents. The delivery of wood and coal was part of everyday existence. (Mulcahy-CHDC.)

The *Virginia Evening Chronicle* was one of several newspapers that served the community for decades. At their height, the dailies were famous throughout the region for expert journalism. With a shrinking population in the 1890s, the newspapers ceased printing, one after the next. Mulcahy documented this place in the 20th century, a sad remnant of former glory. (Mulcahy-CHDC.)

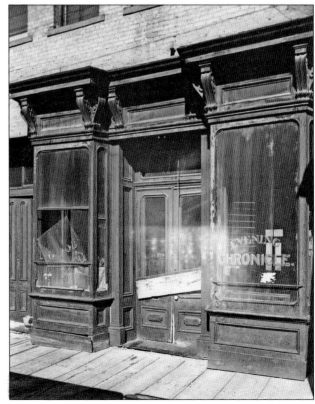

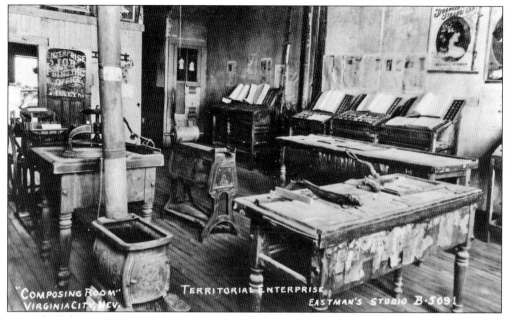

An early-20th-century postcard captures the composing room of the *Territorial Enterprise*, Virginia City's most famous newspaper. It was the center of activity in the 1860s and 1870s, when the Comstock was at its height. The newspaper employed such greats as William Wright, who used the pen name "Dan De Quille," and editor Joseph Goodman, who hired Samuel Clemens. While reporting for the *Enterprise*, Clemens adopted the name "Mark Twain."

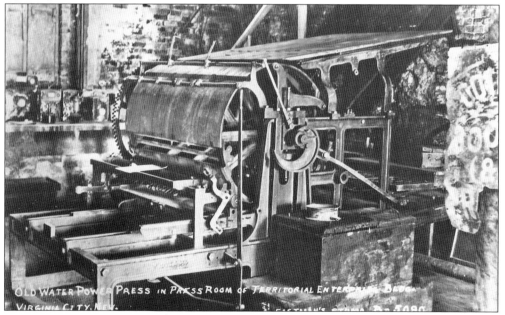

Because it was so prosperous, the *Territorial Enterprise* could afford the latest equipment. This photograph from another early-20th-century postcard features a water-powered press. After leaving the newspaper in 1874, editor Joseph Goodman went on to help decipher the Mayan calendar. Subsequent editors included Fred Hart, who inspired the organization of the Sazarac Lying Club in Austin.

When Mulcahy took this photograph in the 1930s, the *Gold Hill Daily News* office was in ruins, but the saloon next door still stood. It was a favorite watering hole of the reporters. The *Gold Hill Daily News* competed with the *Territorial Enterprise*, but both newspapers had loyal followers. (Mulcahy-CHDC.)

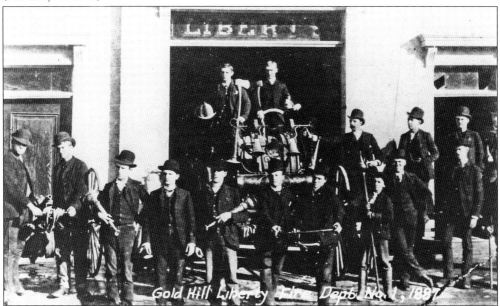

The Gold Hill Liberty Hose Company No. 1 posed for a picture in 1887. The heroes who fought fires saved millions of dollars in property and gave local newspapers good stories. Eventually many volunteers were replaced with full-time employees.

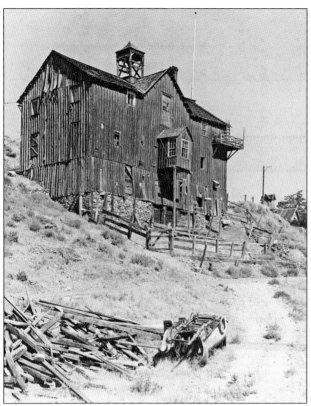

The Incorporated Fire House, perched above Virginia City's B Street, dated to 1875. It was demolished as a fire hazard in the 20th century. (Mulcahy-CHDC.)

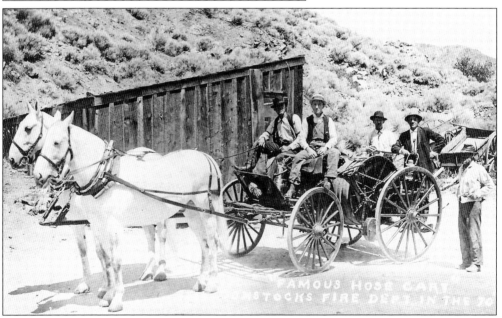

Several men pose with a relic of the 1870s—a hose cart used by early firefighters. This image was probably taken as people prepared for a 20th-century parade. Firefighting equipment improved with national innovations. The Comstock Fire Museum in Virginia City preserves a range of firefighting relics from early hand pumpers to later fire engines.

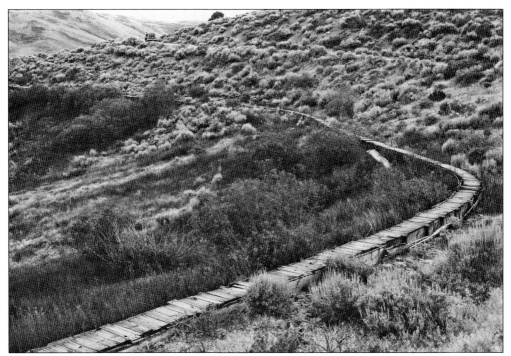
Plentiful water was indispensable for firefighting. Clean water was essential for good health. An 1873 system supplied water to meet both needs. A network of flumes carried water from the Lake Tahoe Basin and then dropped it 1,200 feet in an iron pipe, using the pressure to draw the water back up to the Virginia Range. This was part of the flume system above Virginia City. (Mulcahy-CHDC.)

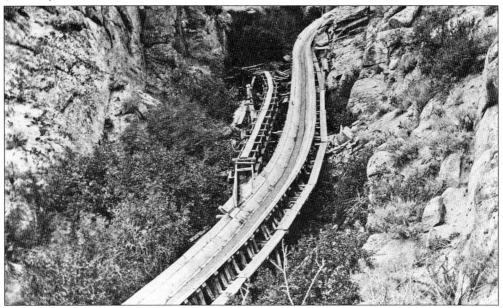
Another type of flume system west of Virginia City carried cut logs to the valley below. The famed "V" flume exhibited a simple design, but it efficiently flushed logs down the steep slopes of the Sierra Nevada range to the valleys. (Mulcahy-CHDC.)

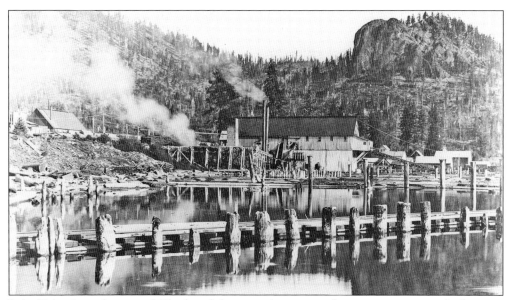

Lake Tahoe's settlement of Glenbrook became the principal processing station for logs cut in the basin. A narrow-gauge engine hauled timbers to the summit to flumes leading back down the other side of the Sierra Nevada. This image shows the community during the 19th century. (CHDC.)

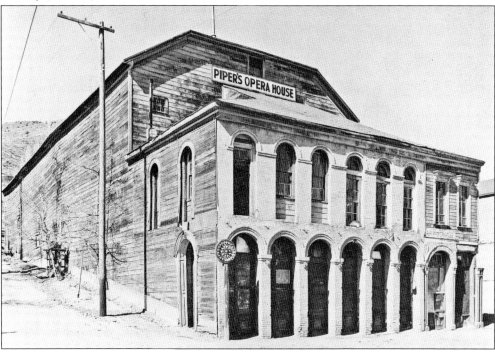

Piper's Opera House, one of the premier theaters of the West, provided entertainment for the community. The great acts of the time appeared there, taking a rest between Sacramento and Salt Lake City. John Piper owned three Virginia City opera houses, the first two destroyed by fire. This one dates to 1885, although the front of the structure was built in 1863. The theater holds performances to this day. (Mulcahy-CHDC.)

A performer, possibly a man named J. D. Corbett, posed in costume, presumably for some role designed to amuse the community during the 19th century. The specifics of where he appeared are lost to time, but the entertainment value of theater and spectacles remains clear. Hundreds of actors, singers, and musicians appeared on Comstock stages. Entertainment ranged from animal fights to Shakespeare's plays.

A home above Piper's Opera House became popularly associated with John Piper, even though the theater impresario lived elsewhere. His former daughter-in-law and her new husband, Dan Connors, did live there. Writers Lucius Beebe and Charles Clegg purchased the house after World War II when they arrived from the East to embrace and transform Virginia City. (Mulcahy-CHDC.)

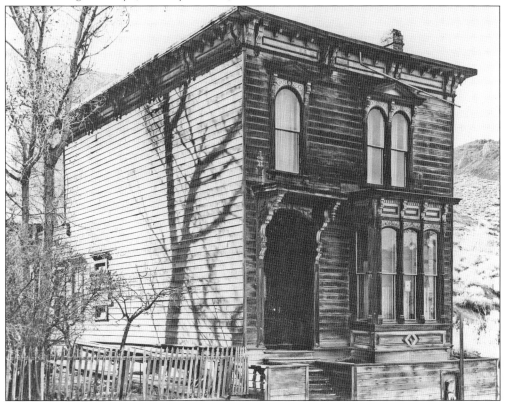

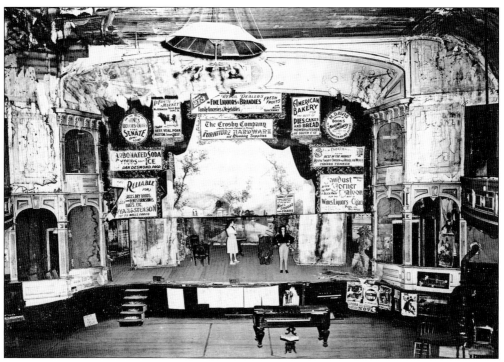

By the mid-20th century, the interior of Piper's Opera House was showing its age, but it still exhibited the grace and glamour that made its stage nationally famous. An olio—a screen that rolled down to block the audience's view of the stage—reveals advertisements for local businesses. The theater became a community center for Virginia City, at times hosting high school basketball games and graduations.

Nineteenth-century photographers were also an important part of the community. John Noe, a local photographer, took this picture of two gentlemen sporting the trappings of wealth that Virginia City offered. They typify the affluence millions of dollars in gold and silver produced. Noe was a longtime fixture of Virginia City commercial life. Thousands of images, like this one dating to 1886, bear the Noe imprint.

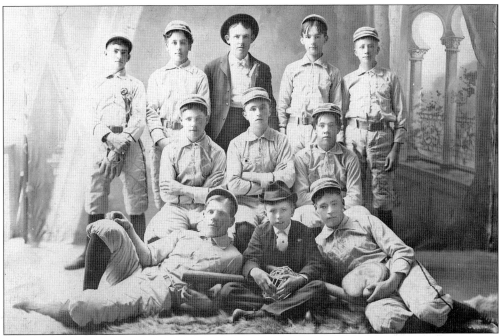

Baseball was a popular sport for the early Comstock. This team posed for a photograph some time in the first years of the 20th century. In 1869, the Virginia City Baseball Club played the Carson City Silver Stars for the state championship. The Silver Stars won—81-31.

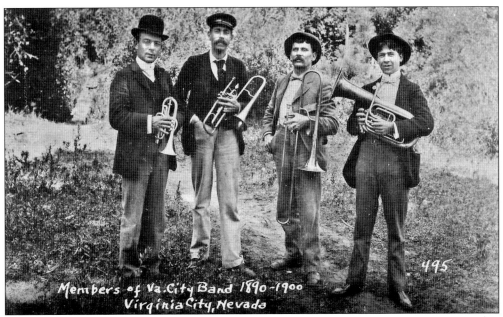

A turn-of-the-20th-century Virginia City band features a variety of brass instruments. Several bands entertained the Comstock throughout the 19th century. With ample venues as well as dances and other events, professional and amateur musicians had numerous opportunities to perform.

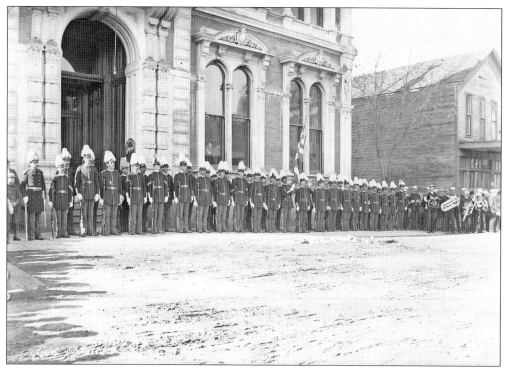

In 1898, the National Guard stands in front of the Storey County Courthouse preparing for a parade in honor of Washington's birthday. The large contingent included a brass band. Virginia City guard units drilled at Fort Homestead, a flattened hilltop overlooking Gold Hill from the northeast.

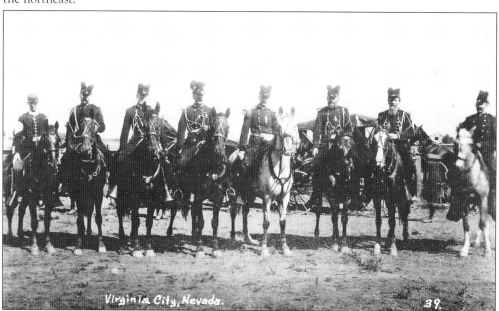

A military cavalry unit, perhaps associated with the National Guard, stopped for a photograph in the 19th century. Images like this were usually captured as units prepared for parades. For the most part, guard units were ceremonial.

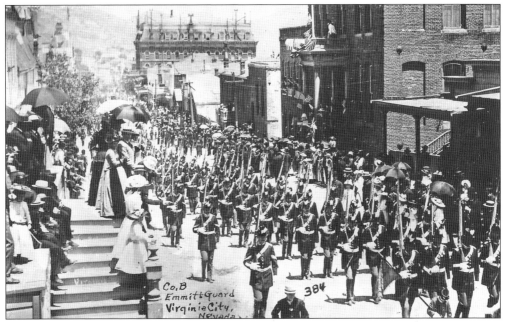

A unit, often identified as the Emmett Guard, paraded along B Street around 1880. Like many early military organizations, the Emmett Guard was initially affiliated with the Fenian Irish revolutionary movement of the 1860s. Several Fenian groups, known as circles, thrived on the Comstock during the 1860s. They sent thousands of dollars to the East in support of Irish independence. When Fenianism faded internationally by the 1870s, other pro-Irish organizations took its place.

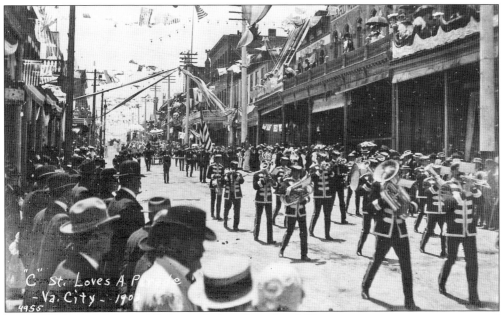

A Fourth of July parade in 1903 featured a large brass band. The community was enjoying renewed mining at the time, and it welcomed everyone for a day of festivities that included a shooting tournament, bicycle races, a balloon ascension, and a high-dive act. Census records from 1870 and 1880 document professional musicians living in Virginia City during its height.

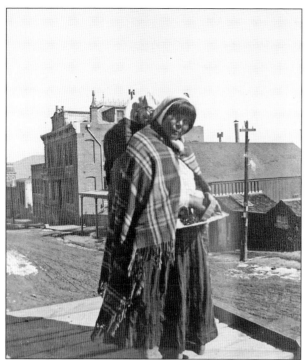

A Native American woman, probably a Northern Paiute, posed with an infant in a cradle board for this 19th-century photograph. She stands on B Street with the Marye Building in the background. Northern Paiutes tended to live on the outskirts of town, but they ventured into the neighborhoods in search of opportunities to make money. Many Native American women worked as housekeepers, laundresses, or seamstresses. Men hired out as laborers.

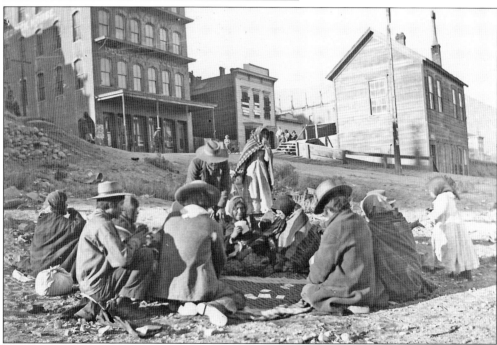

A group of Native Americans plays cards on the corner of Union and D Streets, below the center of town, around 1880. Gambling was a popular precontact diversion for Northern Paiutes, and they continued the practice in Virginia City, even though they borrowed card playing from the newcomers. The Frederick House is the large brick structure in the background, rebuilt after the Great Fire of 1875.

Four

THE BIG BONANZA
THE GREAT MINES

For two decades, from 1859 to the late 1870s, the Comstock Mining District was "in Bonanza," using a Spanish term popular at the time. Mexican miners were part of the ethnic bedrock of the region, and their vocabulary affected the industry and society. To be in bonanza was to enjoy the flush times. Production fluctuated, and there were periods when it seemed the district might fail, but new discoveries renewed the flow of wealth. When miners discovered the famed "Big Bonanza" in 1873, the huge deposit of gold and silver propelled Virginia City into a legendary status that still echoes into the 21st century.

Within the first two decades of the discovery of gold, the district experienced several types of mining. Placer mining extracted gold dust and nuggets from stream beds. After the first 1859 strikes, workers practiced an early form of open pit mining as they scooped ore bodies near the surface out of the ground. Independent entrepreneurs also pursued a crude form of underground excavation using technologies that reached back centuries. These rathole mines rarely proved profitable, but their remnants are ubiquitous. The small excavations left tuffs of pale dirt—material taken from below ground for modest adits and shafts—scattered throughout the region.

The most important Comstock mines were the deep, hard rock excavations that made Virginia City famous. These were the pinnacle of 19th-century technology and engineering. At times dropping down over a half-mile, cages lowered miners by the thousands. Technological innovations included flat-wire cable, square-set timbers, and the safety cage, a self-braking elevator compartment. The Sutro Tunnel was another remarkable Comstock achievement. Designed for drainage, it ascended gradually from the Carson River Valley to the 1,600-foot level of Virginia City's mines. Excavated from 1869 to 1878 and nearly 4 miles long, the tunnel still draws water from the deepest mines.

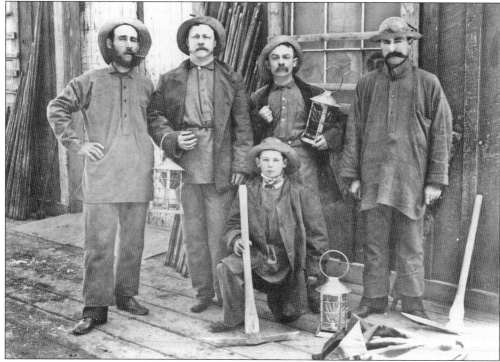

Unlike European mines during the Industrial Revolution, the Comstock shunned child labor. Many boys who reached the age of 15 left school to take high-paying jobs underground, but they were regarded as young men. The workers in this undated photograph may have been part of the Sutro excavation. The youngest of them was either 15 years old or he may have posed for the photograph as something of a mascot. (CHDC.)

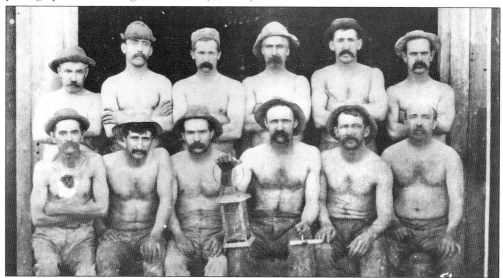

Photographers passing through town would take pictures of shifts of miners to sell to the men, and dozens of these images survive. The 19th-century photographs often feature lamps, miners' candlesticks, and lunch buckets, but too often, nothing is known of the miners' names, the year, or even the mine represented.

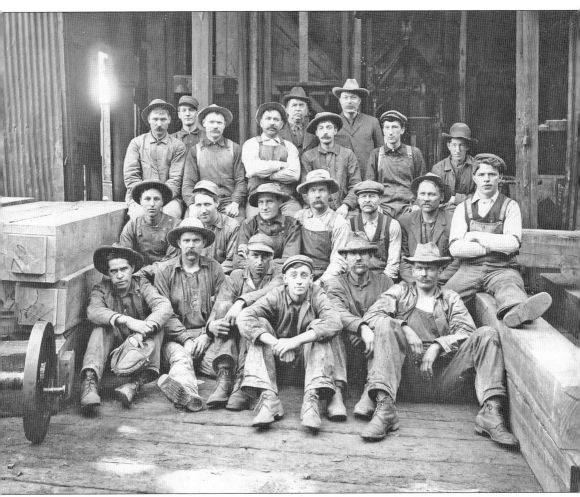

A later photograph of a shift of miners is not framed with the classic, shirtless pose of the workers in rows. The casual nature of this image suggests a c. 1900 date. Lumber prepared for square-set timbering provides a Comstock signature.

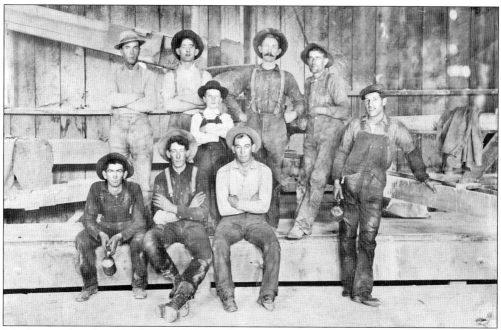

The hats in this photograph suggest that this group of miners worked in the 1920s or 1930s. The tradition of photographs of groups of workers continued, as did underground work, until after World War II. The federal government extinguished gold and silver mining in 1942 because essential materials were needed for the war effort. Underground mining resumed after the war, continuing sporadically, but it never achieved the glory of the previous century.

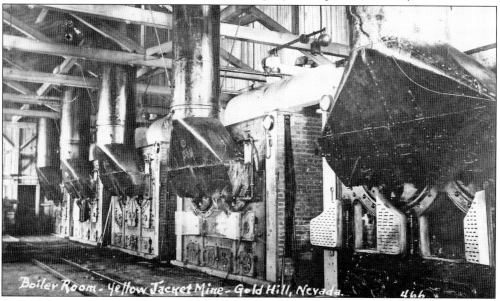

Each of the major mines maintained a boiler room, captured here in this undated photograph. Boilers generated steam for the operation of pumps to draw water from the depths and hoists to raise and lower men, ore, and tools. This facility ran the Yellow Jacket Mine in Gold Hill, and it required its own labor force of wood cutters, teamsters to deliver the wood, and workers who fed and maintained the boilers.

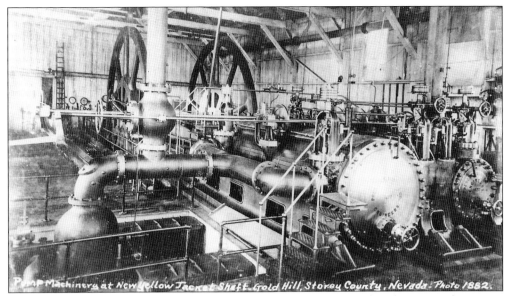

In 1882, the Yellow Jacket Mine's pump room included large pistons that drew water from pipes reaching deep into the mine. Each stroke of a piston could pull hundreds of gallons of water to the surface. Huge fly wheels in the background acted as a counter-balance to increase the efficiency of the machinery.

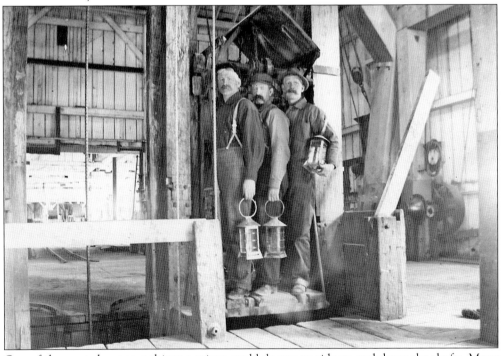

One of the most dangerous things a miner could do was to ride up and down the shafts. Many fatalities occurred during this process. Nevada law prohibited anyone from talking to a working cage operator because the slightest distraction could mean death for those who depended on his attention. The miners in this undated photograph are ready to descend. The cage in the shaft to the left has already dropped to the levels below.

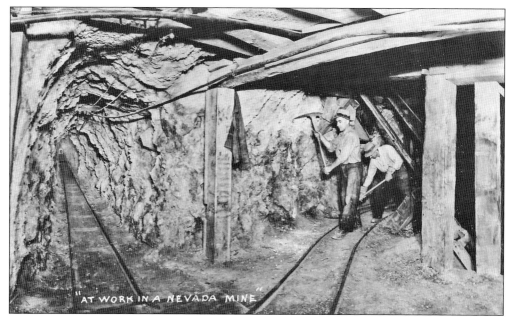

Although this image shows early-20th-century miners, work underground changed little over the years. The basic needs remained: workers blasted rock to follow veins of silver and gold, and they built supports to keep the mountain from collapsing on the excavation. Rails guided ore carts into the depths and then back again, filled with waste rock or valuable ore.

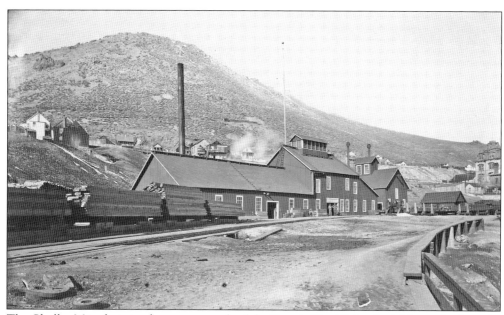

The Chollar Mine hoisting house was south of the Fourth Ward School, visible on the far right of this 19th-century photograph. In the early 1860s, the Chollar Mine and the neighboring Potosi Mine were involved in a legal contest that cost millions. It inspired Nevada U.S. senator William Stewart to seek better national governance of the industry, ultimately yielding the federal General Mining Act of 1872 that remains in effect to this day.

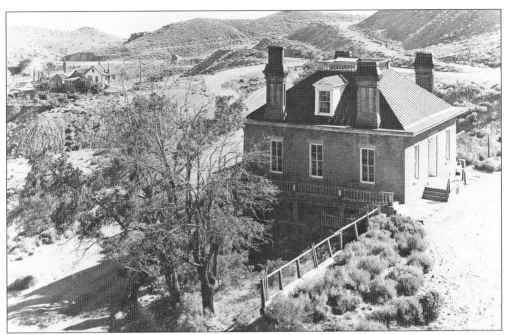

The Chollar Mine Superintendent's Office originally stood four blocks uphill on the slope of Mount Davidson. In 1872, after the mine sunk a deeper shaft to the east, workers moved the two-story brick structure downhill to its present location on D Street, behind the Fourth Ward School. (Mulcahy-CHDC.)

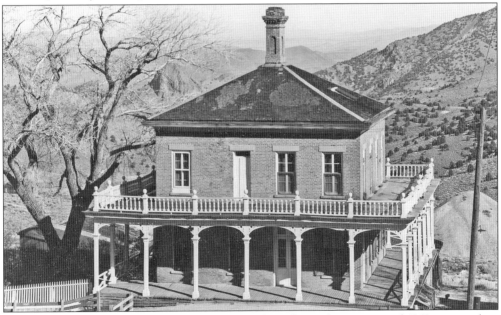

The Gould and Curry Mine office and superintendent's home dates to around 1862, a time when George Hearst owned a significant interest in the businesses. This building is known, however, as the Mackay Mansion because of its later association with John Mackay, who had a commanding share of the Gould and Curry in the 1870s. Mackay probably lived there for several months after the destruction of his house in the 1875 fire. (Mulcahy-CHDC.)

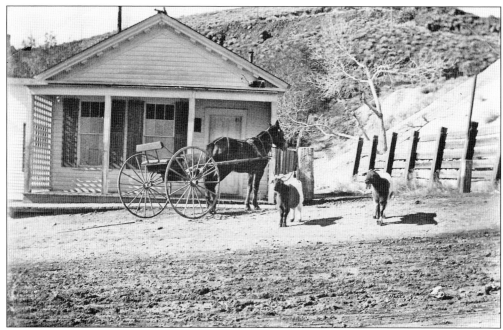

Two goats and a horse pose in front of the Crown Point Mine office in a photograph that probably dates to the 1870s. Gold Hill's Main Street, in the foreground, is a churned mess of mud. Although the Crown Point yielded millions of dollars, its office and setting are humble.

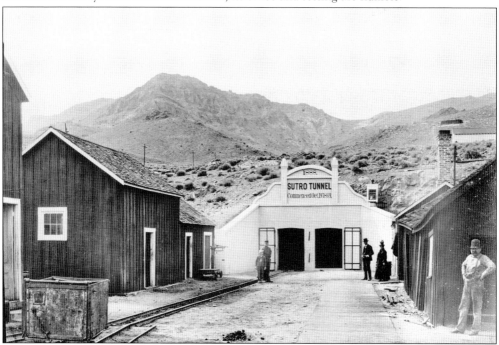

Adolph Sutro built a formal entrance for his Sutro Tunnel in 1888, which dates this photograph to around the 1890s. Excavated between 1869 and 1878, the 3.5-mile excavation provided drainage for Virginia City's mines, but its completion was too late to have much effect on the Comstock. Nevertheless, it remains to this day an engineering marvel. (LOC.)

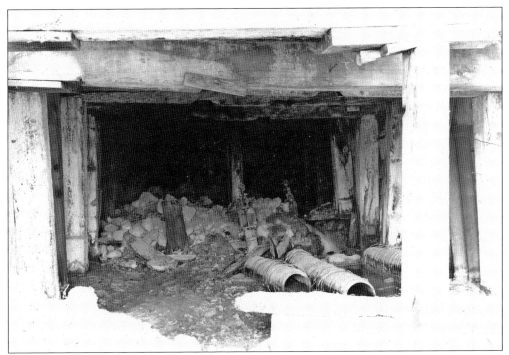

When Mulcahy took this photograph in the 1940s, the Sutro Tunnel was beginning to collapse. Subsequent work strengthened the timbers, and despite further cave-ins, the tunnel continues to act as a passive drain for the mines of Virginia City, down to the 1,600-foot level. (Mulcahy-CHDC.)

The Sutro yard was still filled with the debris associated with the excavation of the tunnel more than 60 years after the fact. Adolph Sutro had hoped his tunnel would shift the center of power and profits to his planned Sutro City, but the mines were beginning to fail, and circumstance did not yield the anticipated wealth. (Mulcahy-CHDC.)

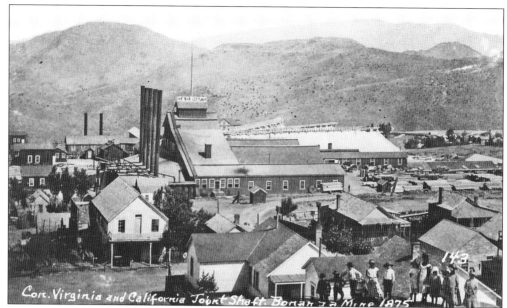

The mighty C&C shaft, the hoisting works for the Consolidated Virginia and California, stood on E Street in the center of Virginia City. The Con Virginia mine ultimately produced a spectacular amount of wealth, making the Comstock known to households internationally. This image purports to date to 1875, but it may be a few years later.

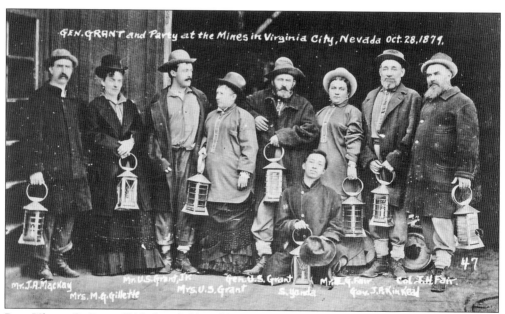

Pres. Ulysses S. Grant (fifth from left) and his family posed with silver barons John Mackay (far left) and James Fair (far right) and also with Nevada governor John Kinkead (second from right). Grant visited the Comstock during his world tour, following his term in office. This photograph commemorates a trip underground on October 28, 1879. Visiting Virginia City's mines was the goal of many 19th-century world travelers.

Five

THE MILLS
TECHNOLOGICAL ACHIEVEMENTS

From the beginning, mills transformed the Comstock from a place of potential into a district that produced a legendary amount of gold and silver. After miners brought ore to the surface, what followed was less dangerous and glamorous than the underground work, but it was nevertheless essential. Millers used a complex process to extract the gold and silver from rock, and in two decades of production from 1860 to 1880, mills produced today's equivalent of nearly $10 billion. Entrepreneurs built dozens of mills throughout the Comstock, but competition was stiff. Many closed quickly, lacking a reputation for the efficient and cost-effective retrieval of precious metals from ore.

Mills followed a process generally employed for millennia, but they also introduced a few modern approaches, some of which were Comstock inventions. Rock had to be crushed, and Virginia City and Gold Hill rumbled with the sound of hundreds of stamps—wood and iron pistons rising and falling—that hammered rock into dust. With the addition of water, salts, and other chemicals, the debris became a pulverized mush mixed in large kettles that churned and heated the concoction. By adding mercury, gold and silver turned into a heavy amalgam that dropped to the bottom. Millers removed the worthless material, and then heated the mixture of metals, driving off the mercury as a vapor and leaving behind nearly pure gold and silver. Afterwards, they separated the gold and silver, creating bars of bullion for shipping.

Much of the bullion was shipped to the U.S. Mint in Carson City, built in 1869. Because a spur of the V&T Railroad led directly to the mint, it was possible to ship bullion securely from a mill to the place where it became coinage. Although the U.S. government purchased tons of gold and silver for currency, the "CC" mint mark is coveted by coin collectors because it is relatively scarce.

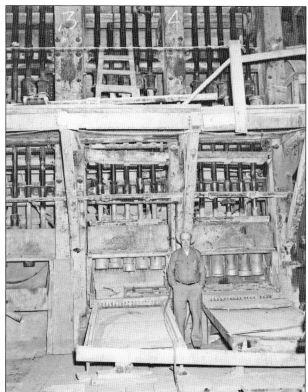

In the mid-20th century, Silver City native Bill Donovan stands in front of the battery of stamps in his mill. Dozens of these iron pistons rapidly rose and fell, hammering rock into powder for further processing. This was an essential but explosive and loud first step in milling. (Mulcahy-CHDC.)

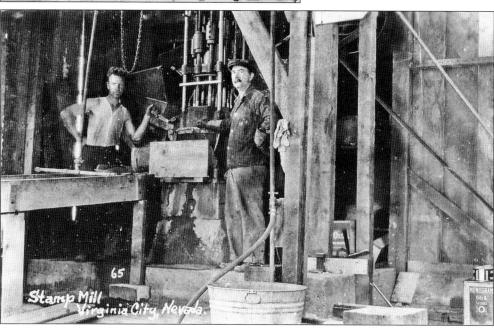

Two workers posed for a c. 1900 photograph in a stamp mill in Virginia City. Technology changed, but the basic principals remained: unlocking precious metals from solid rock required the pulverization of the material. Next millers mixed the dust with chemicals and water, heating and stirring the concoction to separate gold and silver from worthless debris.

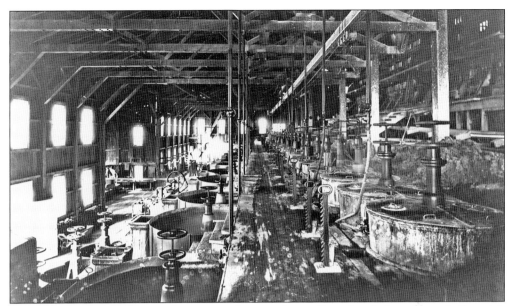

After the stamp mill pulverized ore into a fine powder, millers placed the gold- and silver-rich material into vats filled with water, salts, and mercury. There the brew was churned, mixed, and steam-heated until the precious metals dropped to the bottom as a heavy amalgam. Millers drew off the waste material for deposit on the tailing heap outside. Carleton Watkins captured this image in 1878. (SHPO.)

Mills could produce as much profit as mines since a good miller could charge a great deal for the extraction of gold and silver. The Mexican Mill office and superintendent's home in Empire City on the Carson River rivaled any of its mining counterparts in Virginia City. (Mulcahy-CHDC.)

Only remnants of the Mexican Mill survived when Mulcahy took this photograph in the 1930s. Mills required a good source of water to power their steam engines and to mix with ore in the milling process. The Mexican Mill was one of many that exploited the Carson River. (Mulcahy-CHDC.)

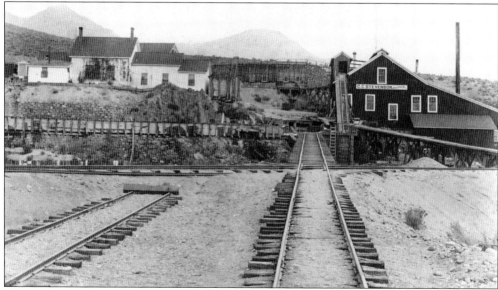

A 19th-century photograph depicts the C. C. Stevenson Mill on the eastern edge of Dayton. Also called the Rock Point Mill, it was one of the larger facilities in Dayton. The mill used water from the Carson River. (CHDC.)

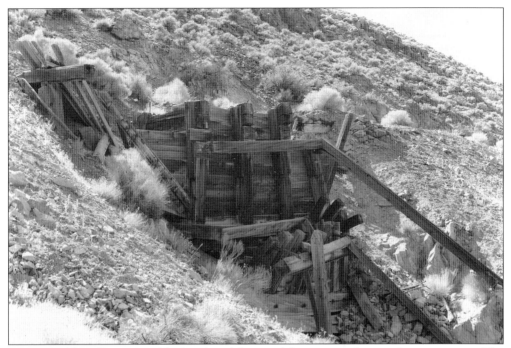

Less profitable mills were quickly abandoned, leaving debris scattered across the entire region. The "slide," a remnant of the internal workings of the Santiago Mill, was little more than a scattering of dry wood by the mid-20th century. (Mulcahy-CHDC.)

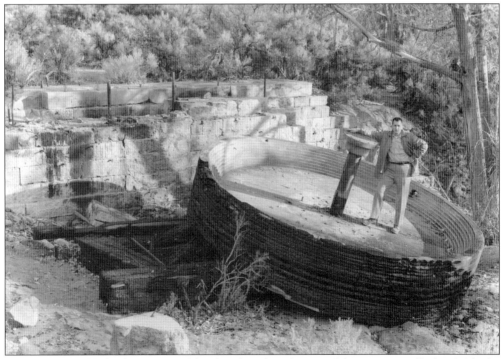

The massive "bull wheel" was part of the abandoned machinery of the Morgan Mill when Mulcahy visited the site in the late 1930s. (Mulcahy-CHDC.)

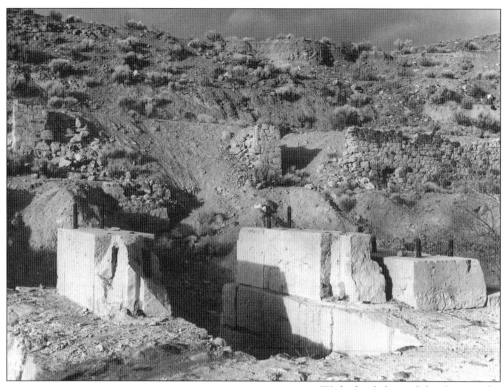

With the failure of the Comstock mines, owners quickly abandoned the Brunswick Mill on the Carson River where it passed through Brunswick Canyon. Without profitable ore to process, mills were the first victims of bad times. Mine owners could afford to continue exploring underground as long as those who held stock did not flinch, but lacking work, mills closed. (Mulcahy-CHDC.)

When Mulcahy visited the Brunswick Mill site in the mid-20th century, he found its massive bull wheel—the heart of the machinery of a once mighty mill—lying in ruins. (Mulcahy-CHDC.)

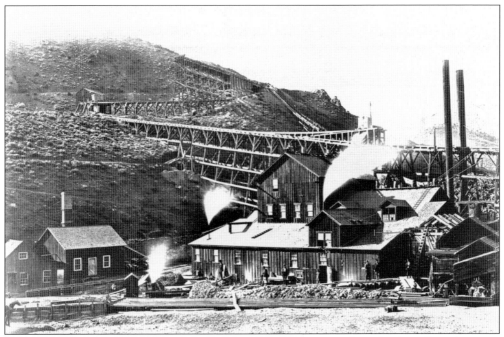

A mill complex in the 19th century featured an extensive system of trestles that allowed carts to deliver ore. Most mills depended on gravity to carry rock from the battery of stamps down through the various stages until amalgam could be taken to the smelter for final processing. (SHPO.)

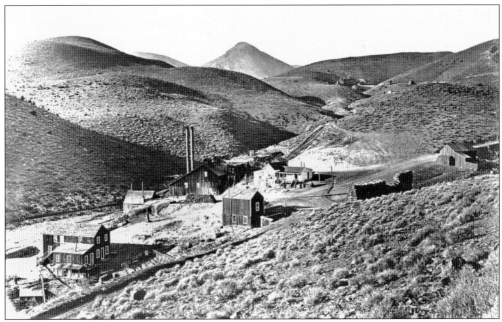

The Occidental Mill, depicted in this 19th-century photograph, was a humble enterprise. It was one of dozens scattered throughout the region, built to process Comstock ore. Some were large, grand affairs. Most were not. (SHPO.)

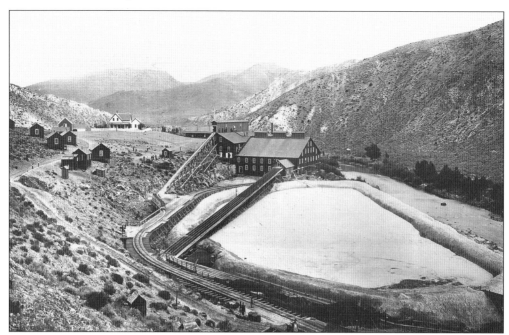

The Eureka Mill, shown here in an undated photograph, was one of many located on the Carson River. With plentiful water for its processing and for its steam engines, the river made for an attractive if remote mill location. (SHPO.)

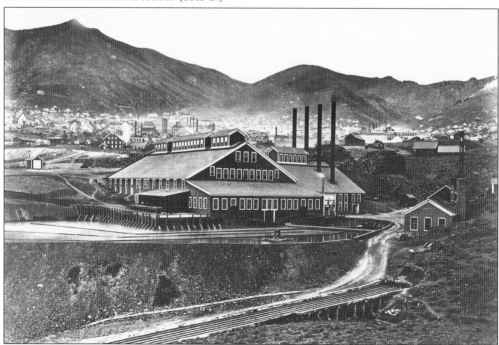

In 1878, Carleton Watkins photographed the Consolidated Virginia Mill complex to the east of Virginia City. It was one of a few mills operating in the community, since most were located near plentiful water, removed from town. The Con Virginia was one of the richest mills working Comstock ore. (SHPO.)

Six

EDUCATION
FROM MINING CAMP TO FAMILY TOWN

The residents of the Comstock made the education of their children a priority from the earliest days of the community. Three Virginia City teachers appeared in the 1860 federal census, just 13 months after the first mineral strikes. The presence of the educators dispels the popular conception of a rough-and-tumble mining camp that included many miners and a few women of questionable reputation. In reality, families quickly arrived, and although children were slow to make up a significant part of society, they required the presence of schools.

Virginia City government organized the community into four political subdivisions, or wards, adding Gold Hill as a separate precinct to the south. By 1870, each ward had a public school that offered an education to hundreds and then thousands of young scholars. Parents also had the option to send their children to private or religious schools, including the institution run by the religious order Daughters of Charity of St. Vincent de Paul.

When the Great Fire of 1875 leveled the core of Virginia City—including the Second Ward School—the community began an aggressive building program to replace the structures it had lost. In June 1876, the town's school board trustees purchased a lot at the south end of C Street near the Divide and announced construction plans for a large new school in the Fourth Ward. When it welcomed its first students in January 1877, the Fourth Ward School boasted the latest amenities, standing as a testament to Virginia City's wish that students receive the best education possible.

As the mining district moved into decline and funding for education grew scarce, teachers continued to give the Comstock's children a chance to reach great heights. For decades, many Nevadans could claim a parent or grandparent who emerged from Storey County's schools. One of the school district's alums, Albert Michelson (1852–1931), measured the speed of light and won a Nobel Prize.

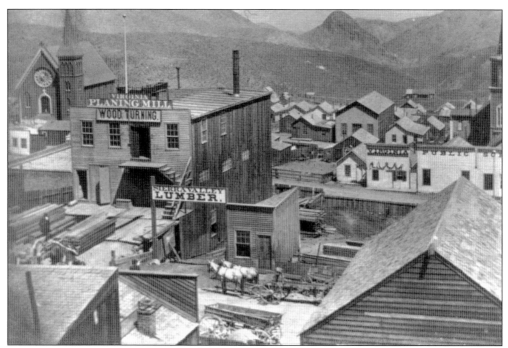

An early photograph of Virginia City reveals a public school nestled among businesses, houses, and churches. Often without formal educations, the miners who helped to settle the town wanted their children to receive a fine education. Enthusiasm for learning permeated the district, inspiring a higher than average school attendance and community participation at school events. (LOC.)

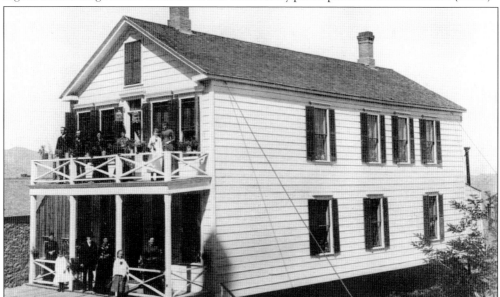

Virginia City's First Ward School, depicted here in a 19th-century photograph, opened in 1874 at the north end of C Street. When the 1875 Great Fire destroyed the Second Ward School, students crowded into the First and Third Ward Schools. Teachers throughout the community faced the challenges of enormous class sizes, poor ventilation, and unsanitary conditions conducive to illness. By 1876, the need for a new, modern structure had reached a critical point. (NHS.)

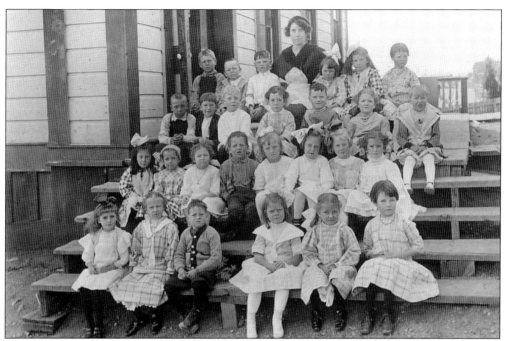

Like the students of all the schools in the Comstock mining district, the children who attended the First Ward School reflected the ethnic diversity of the Comstock. The modest, two-story structure served scholars living on the north end of Virginia City, and it was the first large building to welcome visitors entering the town from Geiger Grade. Younger students appear in this c. 1900 photograph. The First Ward School was demolished in 1936.

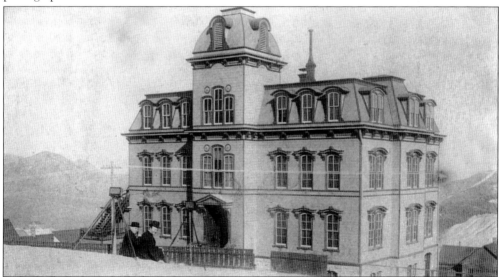

Virginia City's Fourth Ward School debuted with a day-long community celebration on November 28, 1876. Standing as a tribute to the nation's centennial, the Second Empire–style structure boasted modern amenities such as indoor restrooms, gas lighting, forced-air heat, drinking fountains, a patent ventilation system, and room for 1,000 students. The design for the building was likely based on a plan from a 19th-century architectural pattern book. Two photographers posed for this undated image.

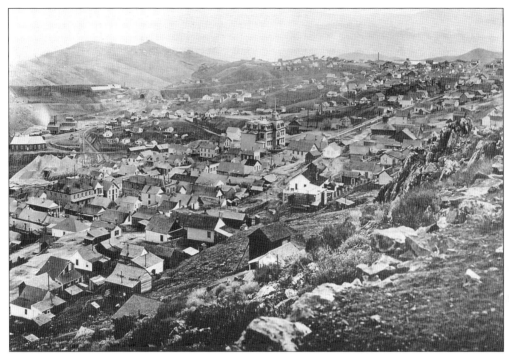

When Carleton Watkins photographed the southern part of Virginia City in 1878, the new Fourth Ward School rose majestically in a crowded place where homes, commerce, and industry coexisted as neighbors. Many students were forced to walk through the Barbary Coast, an unsavory C Street neighborhood known for its crime, opium dens, and prostitution.

Fourth Ward School teachers, such as the two in this undated photograph, were among the highest paid educators in the state. Virginia City's school district required prospective instructors to pass grueling examinations in a wide variety of topics before they received a teacher's certificate. Graduates of the school were sought after for teaching positions in Nevada and California.

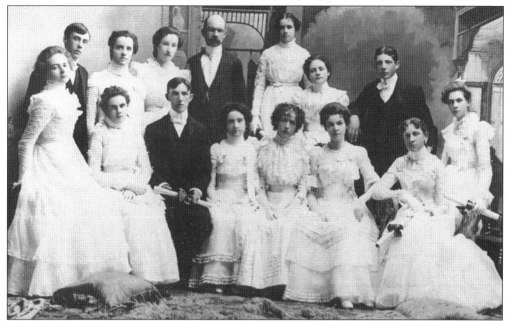

In 1889, graduates of the Fourth Ward School's high school department dressed in stylish attire for a formal commencement event marked with student recitations of poetry and prose, musical performances, and a graduates' promenade. In 1878, the Fourth Ward's high school department was the first in the state to award a diploma for the successful completion of grades 1 through 9. Grades 10 through 12 were added by 1909.

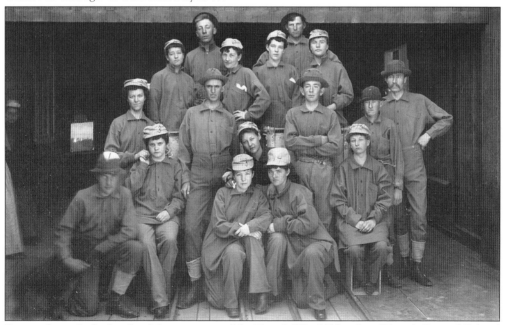

Seniors from the high school departments of the Fourth Ward School and Reno's Central School posed for a group photograph after touring Virginia City's mines in May 1895. The Fourth Ward served Virginia City's scholars until 1936, when its last class graduated and a new school was built in the center of town.

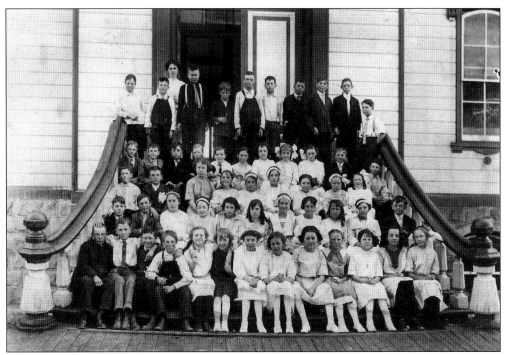

The fifth- and sixth-grade classes filled the stairs of the Fourth Ward School in 1908. The steps became the setting for decades of class photographs that immediately identify Virginia City's distinguished schoolhouse. Modern preservation efforts have completely refurbished the building's famous staircase.

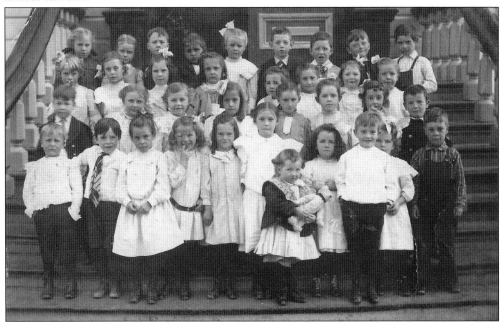

Second and third graders dressed in their finest attire to have their class photograph taken on the steps of the Fourth Ward School in 1911. A younger child clutches her stuffed bear, perhaps anxious about her own impending school attendance.

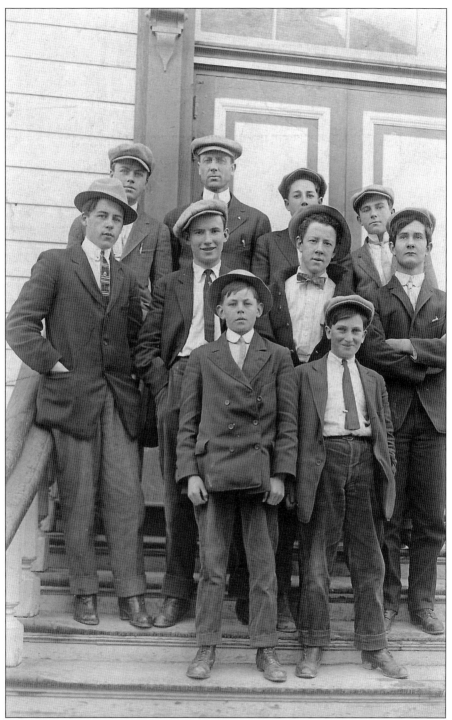

A group of boys and their teacher achieved a confident pose near the front doors of the Fourth Ward School when this photograph was taken in 1911. In Virginia City, girls often outnumbered boys in graduating classes, the latter having left school early to help bring additional income to their families.

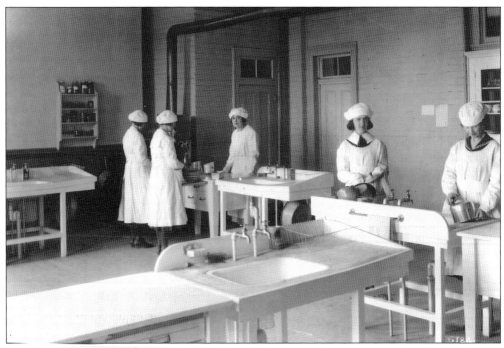

Home economics students at Virginia High School prepared meals in 1921 under the watchful eye of their teacher (third from left). Fourth Ward School officials converted part of the basement into a home economics room when national educators called for more practical high school curricula that included domestic science courses for girls and manual training for boys.

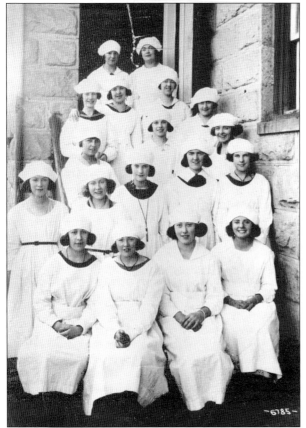

Dressed in their crisp white uniforms and caps, Virginia High School home economics students moved from the classroom to the side stairs of the Fourth Ward School for a photograph with their teacher in 1921. Their nurse-like attire conveyed the need for sanitary conditions during food preparation.

High school girls enjoyed a day of fun after they climbed Mount Davidson to apply a fresh coat of paint to the "V" above Virginia City. The town's population had declined dramatically by the time this picture was taken in 1935, with class sizes shrinking to fill just a few classrooms of the Fourth Ward School.

Another photograph of the 1935 trip to paint the V shows one student with a block "V" sweater. Students who attended the Fourth Ward School remembered the warm embrace of dedicated teachers and camaraderie among their classmates.

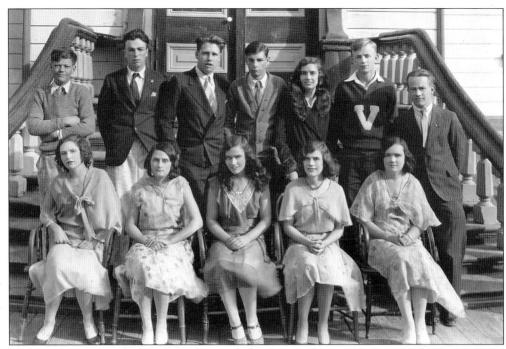

The costumed Virginia High School cast of *Blundering Billy* poses in front of the Fourth Ward School in 1931. Lighthearted comedies gave students and their audiences an opportunity to escape from the bleak reality of the Great Depression and the town that was crumbling around them.

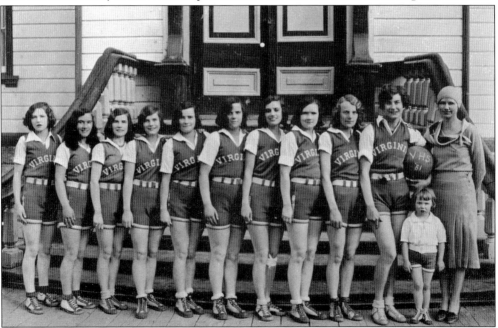

The 1931 girls' basketball team posed at the base of the Fourth Ward School's famous stairs five years before the closure of the legendary schoolhouse. The Virginia High School players practiced their moves in the small gymnasium in the unfinished top story of the school. Home games were played at Piper's Opera House and the National Guard Hall.

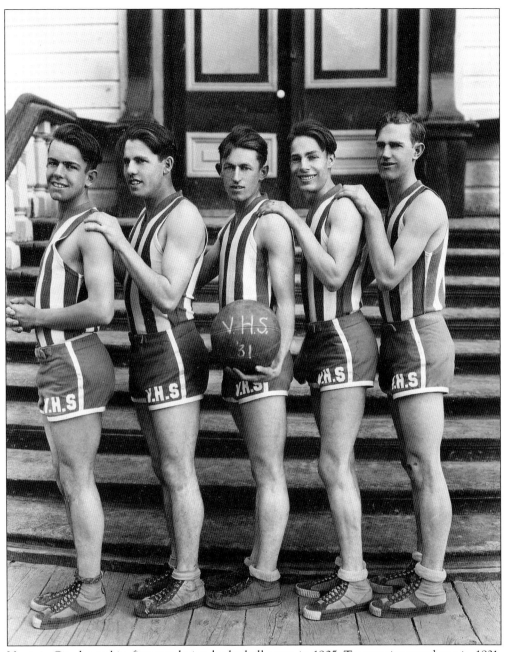

Virginia City hosted its first regulation basketball game in 1905. Twenty-six years later, in 1931, the boys' team showed off their uniforms in front of the Fourth Ward School. The team was known as the "Muckers," taking the name of the hardworking miners who shoveled, or "mucked," out shattered rock after a dynamite explosion.

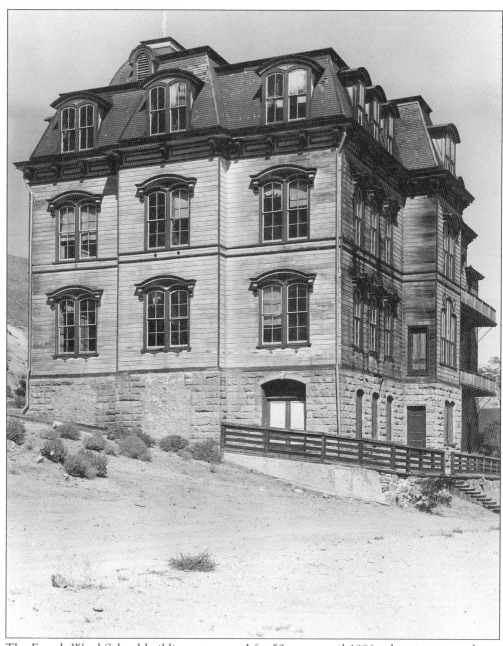

The Fourth Ward School building sat unused for 50 years until 1986, when it reopened as a museum. A recent nationwide survey indicates the remarkable nature of this survivor. After an extensive restoration program to stabilize the building, the Fourth Ward remains largely unchanged since its 19th-century debut. Its many counterparts across the country have been demolished or significantly modified. (Mulcahy-CHDC.)

Seven

BORRASCA
VIRGINIA CITY BARELY HANGS ON

The Comstock boomed from 1859 to the late 1870s. The mines had endured fluctuations during those 20 years, but that only blinded most to the severity of the decline that settled in by the late 1870s. Many lingered, certain miners would find another ore body that would spawn the next bonanza period. The mining district had always been the setting for a struggle between optimists and pessimists. Those who believed every downturn was a final chapter left for the latest mineral strike elsewhere. Others held out, believing they would win their reward by being first in line for the best jobs when the good times returned. The Comstock eclipsed many other Western mining camps because of its longevity, but ultimately, it too succumbed to the fact that ore is an elusive, nonrenewable resource.

By the 1880s, Virginia City was clearly sinking into a profound *borrasca*, a Spanish term commonly used to describe a period of mining depression. During the middle of the decade, pumping ceased and water flooded the deeper mines, cutting off further exploration. Nevertheless, optimists persisted and hoped for better days. A mini bonanza replenished the district after the dawn of the 20th century. Cyanide processing—a new, more efficient way to treat ore—brought further vibrancy, but it was short-lived. Sporadic attempts to pursue mining produced little more than dashed hopes. For a while, chalk mining replaced the glamorous excavations for gold and silver that once captured the attention of the world.

Comstockers scattered throughout the mining West, and wherever they went, they were recognized as having worked one of the world's most famous districts. A few remained, however, clinging to the old place even as it began falling down around them. By 1930, the federal census documented less than 700 residents in all of Storey County. Many Comstock buildings succumbed to the elements, neglect, and sometimes to the quest for firewood. At times, it seemed the town would disappear altogether.

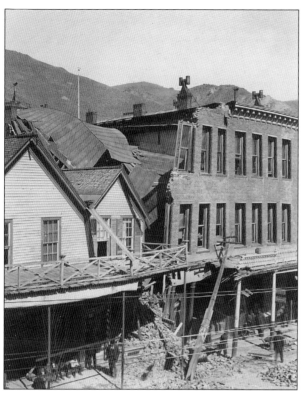

The 1898 collapse of the south wall of the Douglass Building, now home to the Washoe Club Saloon, was a sign of things to come. Masons reconstructed a two-story building out of the debris, and the rest of the structure remained standing. The original building dates to the early 1860s, and its saloon still serves visitors. The Washoe Club is one of the best preserved of its kind.

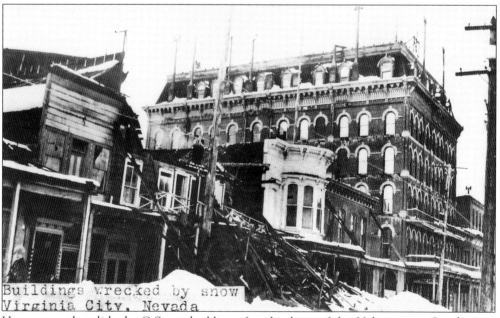

Heavy snow demolished a C Street building after the dawn of the 20th century. One by one, many historic buildings succumbed to neglect or the elements. A fire in 1914 would destroy the grand International Hotel, the six-story structure to the right. As the population dwindled and wealth became only a memory, those who remained were often helpless as they watched their community decay.

In the 1930s, Mulcahy documented the ruins of the Gould and Curry Mine in the foreground with the remnants of the Wells Fargo building rising above. The Gould and Curry had produced millions of dollars in its day, and it had launched the career of George Hearst, but nothing could protect the company from the reality of having no more ore to mine. (Mulcahy-CHDC.)

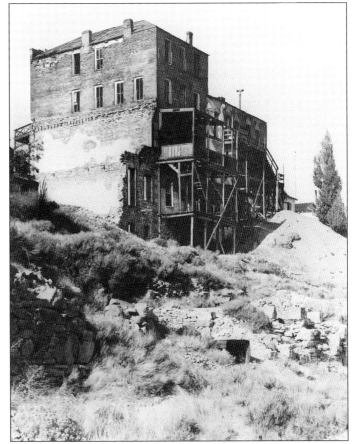

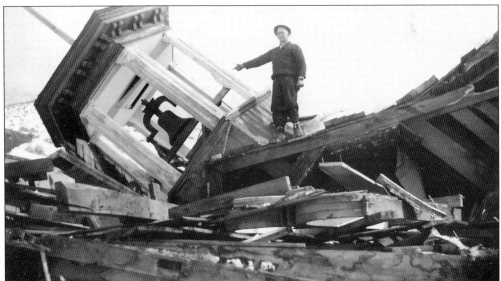

The January 1952 collapse of the Liberty Hose Company No. 1 firehouse in Gold Hill left the bell tower intact. The community salvaged it as a relic of the past. The tower remains as a monument to the firefighters, but the rest of the building was lost.

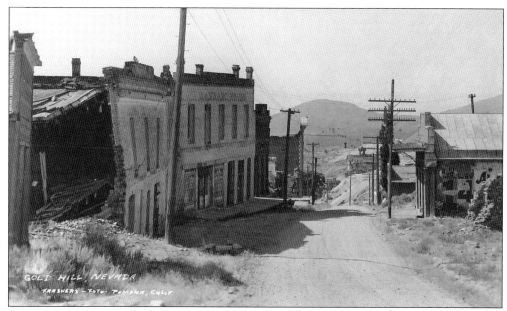

After the 1880s, most residents of Gold Hill either left the Comstock or moved to Virginia City. Buildings along Gold Hill's once-vibrant Main Street disappeared more quickly than their Virginia City counterparts, because neglect began earlier and lasted longer. Today Gold Hill has a surprising number of restored historic structures that survived a time when few were there to save what remained. Gold Hill appears here in an early-20th-century postcard.

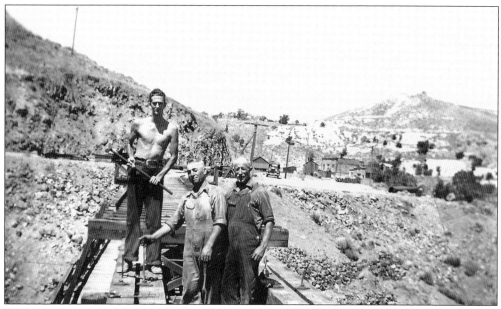

Workmen demolished Gold Hill's famed Crown Point Trestle in 1936. Ty Cobb, a future Reno journalist, poses shirtless with two unidentified men. The Crown Point Ravine is now filled with debris from subsequent mining. Today the new V&T Railroad traverses that section of its right-of-way without the glamorous ride across the breathtaking trestle.

The Combination Mine dump survived, reminding residents of the deepest shaft on the Comstock. Miners in the 1880s descended 3,200 feet below ground, but they failed to find the next bonanza that would have kept the community vibrant. (Mulcahy-CHDC.)

By the time Mulcahy took this photograph, perhaps as early as the 1940s, little remained of what had once been packed neighborhoods along Virginia City's streets downhill from the main thoroughfare and north of Union Street. These blocks included a private hospital, dozens of homes, and a Chinatown with over 1,200 Asians. (Mulcahy-CHDC.)

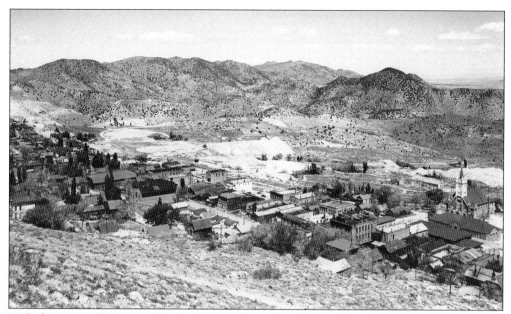

Mulcahy captured Virginia City looking northeast from Mount Davidson. The population had dwindled, and many buildings that remained were abandoned. Fortunately, spectacular vistas were unaffected by economic downturns. (Mulcahy CHDC.)

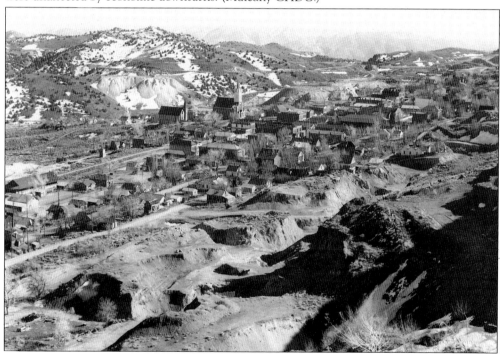

For this portrait of Virginia City from the 1930s, Mulcahy looked to the southeast, positioning his camera on the edge of the Ophir Pit, a glory hole first opened in 1859. The Comstock had its start with the Ophir claim after miners discovered enormous quantities of gold and silver. Open pit mining followed until workers realized they would need to excavate underground. (Mulcahy-CHDC.)

A staircase to the Chollar Mine superintendent's house is choked with sagebrush and weeds. After restoration, the building has served as a bed-and-breakfast and a house museum. (Mulcahy-CHDC.)

Mulcahy's camera captured buildings on the west side of C Street standing in ruin with the Graves house, known as the "Castle," looming above on B Street. The brick building was once a funeral parlor. Mulcahy documented many structures in the historic district that no longer survive. (Mulcahy-CHDC.)

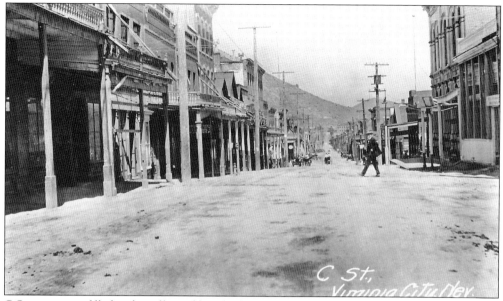

C Street—once filled with traffic and hundreds of people—was nearly empty by the first decades of the 20th century, when this photograph was taken. With few mines producing gold and silver, and with no other means of support, most people left the community. It was difficult to imagine a viable future, and it seemed Virginia City might join the hundreds of other Western mining camps by becoming a ghost town.

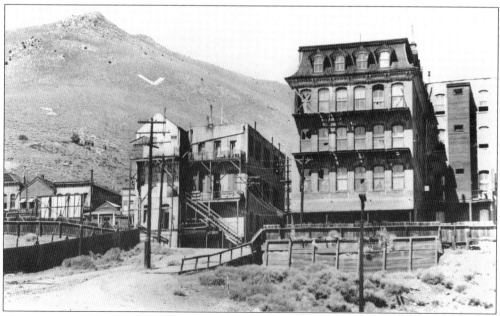

The once-proud five-story Frederick House, with its distinguished mansard roof, has broken windows and awaits demolition in this early-20th-century photograph. The building to its left survived and is home to the popular Bucket of Blood Saloon, founded in the 1930s by the McBride family. (SHPO; courtesy of the late Don McBride.)

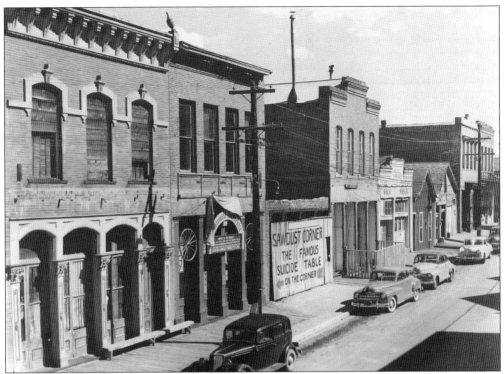

The east side of C Street around 1950 survived remarkably intact. Lured by stories of Virginia City's legendary past, visitors began arriving, hoping to glimpse the Old West. Structures in Mulcahy's photograph include the Panelli building on the far left and the *Territorial Enterprise* building to the right. (Mulcahy-CHDC.)

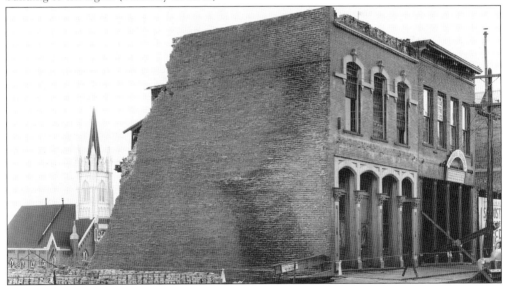

The Panelli Building faced demolition after its back end collapsed following years of deferred maintenance. The *Territorial Enterprise* building survived, as did St. Mary in the Mountains to the rear. In 2008, the church received a Save America's Treasures grant from the National Park Service. The site of the Panelli Building remains empty and abandoned. (Mulcahy-CHDC.)

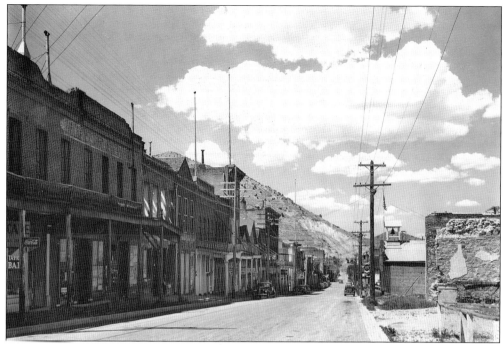

A quiet main street that once echoed with wealth and excitement created its own allure in the mid-20th century. Early tourists found their way to Virginia City, but they were initially few in number.

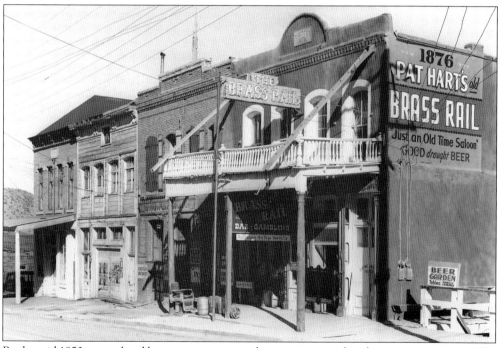

By the mid-1950s, some local business owners were beginning to market the community's past. The sign reads "Pat Hart's Old Brass Rail," and it adds "Just an old time saloon" with "good draught beer." Residents used the trickle of tourists to keep Virginia City alive. (Mulcahy-CHDC.)

In this photograph, an old iron fence stands in disrepair and now defines the perimeter of the Storey County Courthouse yard. Relics like these began attracting early tourists, and Mulcahy documented them before many were stolen by visitors. (Mulcahy-CHDC.)

Mulcahy captured an image of an old stone wall that supported a two-story building, teetering before collapse. His photograph may date to the 1950s, when decades of neglect left much of the Comstock in ruins. Over half of the buildings that stood during the 1870s have been reduced to rubble. (Mulcahy-CHDC.)

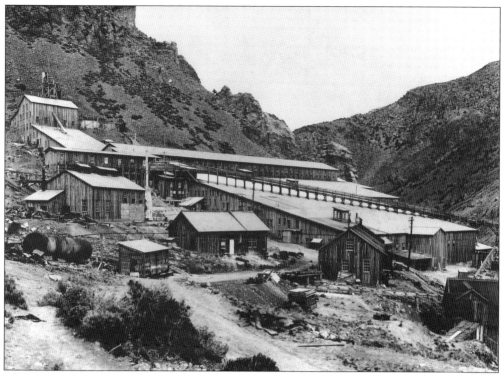

The Butter's Mill to the east of Virginia City—down Six Mile Canyon and at the base of Sugarloaf Mountain—represented an early experiment in cyanide processing. This photograph was taken shortly after Charles Butter built the facility in 1901. The inexpensive use of cyanide to extract microscopic gold allowed for the milling of less valuable ore, giving new life to mining districts with marginal deposits. (SHPO; courtesy of John McCarthy.)

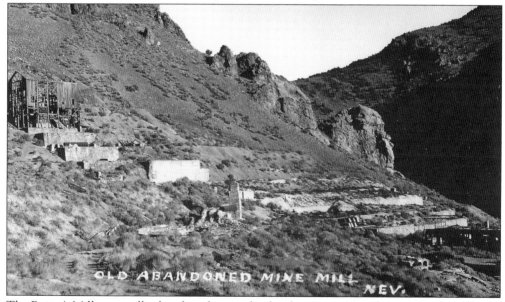

The Butter's Mill eventually closed, and most of its hardware was taken for use elsewhere. By the mid-20th century, little more than foundations survived.

For a time after the beginning of the 20th century, the Comstock's cyanide mills processed ore from the central Nevada mining boomtowns of Tonopah and Goldfield. It felt like the old times had returned, but by 1910, the excitement had dwindled and Virginia City resumed its decline.

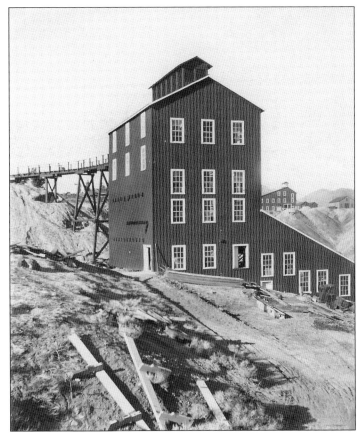

An early-20th-century foray into chalk mining provided employment for local labor. Although digging for chalk employed some people, it lacked the glamour and wealth of the old days, when men retrieved tons of gold and silver from underground.

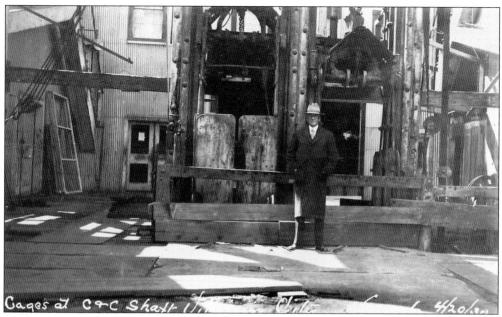

On April 30, 1930, a man poses in front of the cages of the Consolidated Virginia and California Shaft, once the richest mine on the Comstock. Hundreds of miners descended to work the ore below, but by 1930, the facility was little more than an industrial relic.

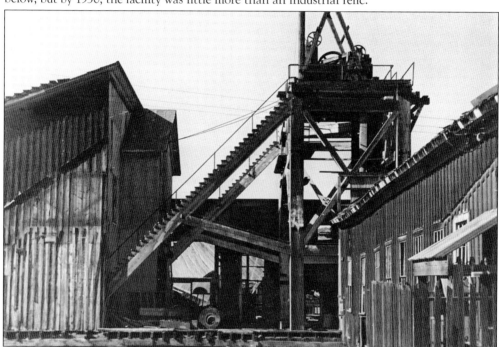

Mulcahy documented the outside of the Con Virginia hoisting works in the 1930s. In 1877, within months of Thomas Edison securing patents for his invention, silver baron James Fair installed an early telephone at the mine. This allowed those at the surface to talk to workers on the 1,500-foot level. Once an expression of the Comstock's industrial might, the legendary Con Virginia complex succumbed in stages. (Mulcahy-CHDC.)

Eight
Celebrating the Wild West
Virginia City Welcomes the World Again

With the first decades of the 20th century, Virginia City's population steadily declined until Storey County—once home to as many as 25,000—now had only slightly more than 600 residents. Although the Comstock communities seemed on the verge of evolving into ghost towns, Virginia City slowly took on a new persona, becoming a destination for those in search of the Wild West. Businesses including the Bucket of Blood Saloon and the Museum of Memories opened to cater to tourists who found their way to the splendid but faded capital of mining. Handfuls of Eastern artists and refugees from high society arrived, settling or passing through and doing their best to fit in with local descendants of workers who had built a legend.

The 1940 premier of *Virginia City*, starring Errol Flynn, Miriam Hopkins, Randolph Scott, and Humphrey Bogart, brought further attention to the Comstock. Those captivated by the place included East Coast bon vivant Lucius Beebe, who settled in Virginia City after World War II. Beebe and his partner, Charles Clegg, published books on the Virginia and Truckee Railroad as well as other Comstock topics. They purchased the *Territorial Enterprise*, turning it into a nationally popular weekly that drew on the romanticism of the West.

In 1959, the Comstock celebrated the centennial of the first strike, commemorated with a U.S. postage stamp and a visit by Vice Pres. Richard and Pat Nixon. Virginia City was reemerging into the nation's awareness. The entertainment industry responded in the fall of 1959 with the premier of the television show *Bonanza*. The resulting flood of tourists transformed a sleeping, quaint relic into a vibrant place that enjoyed a flush time rivaling anything of the 19th century. For Beebe and Clegg, it seemed something of the Old West faded with the arrival of every sightseer. Still, the visitors brought revenue that kept the Comstock alive. Profits meant restoration projects were possible, and buildings that seemed lost were brought back from the abyss.

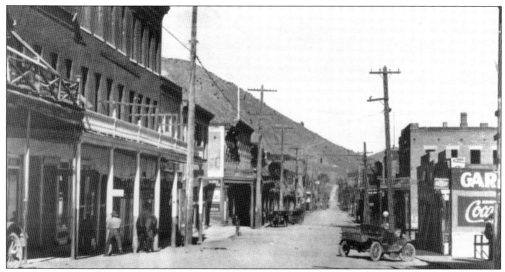

By the third decade of the 20th century, the once-busy main street of Virginia City was nearly abandoned except for a few cars and, on the left, a horse, a remnant of the previous era. The romantic image of a Western ghost town, combined with the lingering reputation as one of the world's greatest mining districts, attracted some tourists and a few new residents. (SHPO.)

Virginia City's main street appears in this mid-20th-century Mulcahy photograph. Nineteenth-century painted letters advertising a clothing store appear above the second-story window sign. Two modern businesses include Ted's Café and the Quality Market, with groceries, meats, and, of course, Coca-Cola. The town had faded, but local residents still needed the essentials to survive. (Mulcahy-CHDC.)

This part of South C Street did not burn during the Great Fire of 1875. The brick and wood buildings on the left, featuring metal awnings, probably date to the earliest period of Virginia City's development in the 1860s. They survive to this day. The preservation of many early buildings makes Virginia City one of the more remarkable historic mining districts in the West. (Mulcahy-CHDC.)

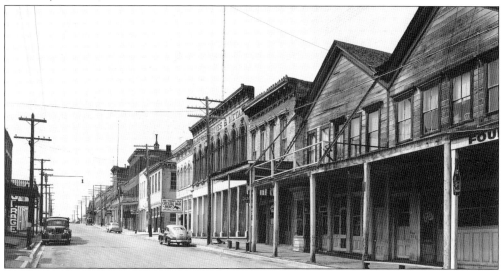

Virginia City's main street had grown quiet during first half of the 20th century. Revenue was scarce, but enough locals hung on to keep the place alive. With the 1959 debut of the television show *Bonanza*, the streets filled up again with tourists looking for the home of the fictional Cartwrights. (Mulcahy-CHDC.)

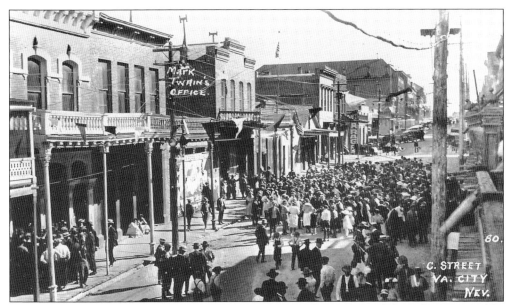

Virginia City was always a sentimental favorite for many in the region, and they often returned for special events. This photograph depicts a gathering, perhaps in the 1920s. The 50th anniversary of the strike, celebrated in 1909, garnered some attention. The community also drew crowds for parades on the Fourth of July and for Labor Day.

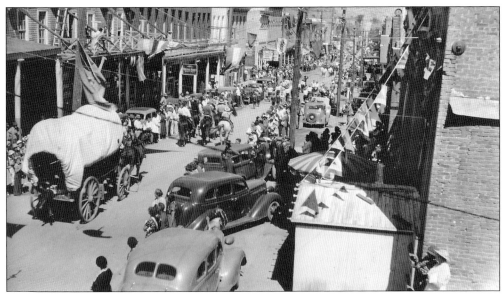

A parade in the late 1930s filled Virginia City's main street with cars, horses, and a wagon, blending the modern with the Wild West. Virginia City was beginning to develop the allure that would make it a tourist destination. Although the town represented a remarkably well-preserved expression of the earliest chapter in Western mining history, it remained a place where descendants continued to live, making it far more than a movie prop or an outdoor museum.

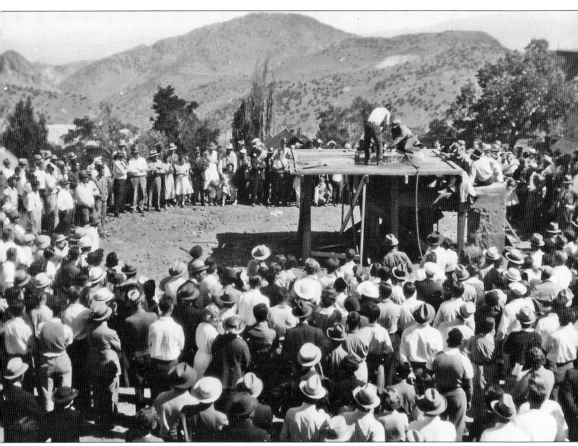

A Labor Day celebration in 1936 featured men competing in a rock drilling contest. By the 1870s, compressed-air drills had replaced most handheld drill bits and heavy, iron sledge hammers known as jacks. Still, using the old tools was a way for men to show their prowess as well as their respect for the old-timers who had made Virginia City great.

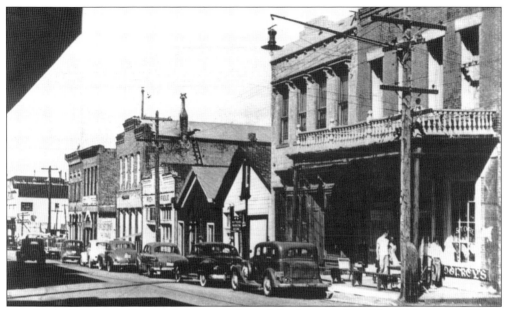

The shock of declining Comstock fortunes plagued the first decades of the 20th century. Those who remained in the mining district strove to make Virginia City a home and a place where residents could make a living. A line of cars suggests some amount of prosperity. At least a few of the vehicles probably belonged to early tourists. (SHPO.)

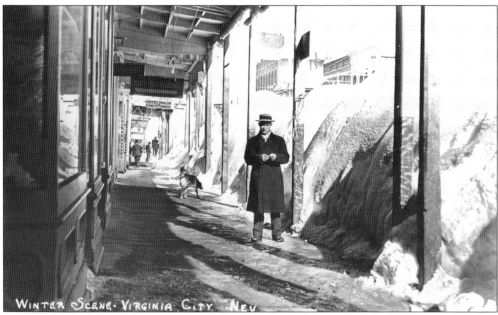

Regardless of the attempt to open Virginia City to visitors, a fierce winter could cut the community off from the rest of the world. As long as the Virginia and Truckee Railroad still operated, snow plows cleared the route to bring supplies. After World War II, a phenomenal snowfall meant simply making due with what was on hand.

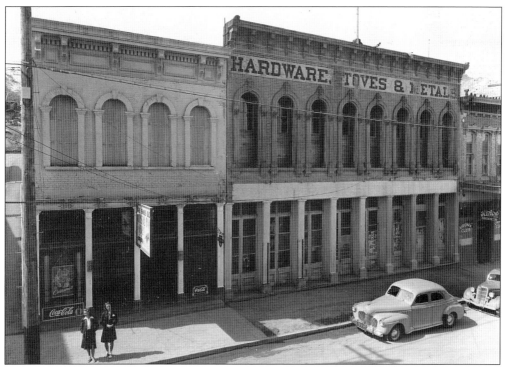

World War II inspired Pres. Franklin Roosevelt to cut off essential supplies used in gold mining. That, combined with gas rationing and the distractions of far-off battles, left Virginia City with few prospects. The town slowly regained an economic footing after the war. Some underground exploration resumed, and tourists began to arrive in increasing numbers. (Mulcahy-CHDC.)

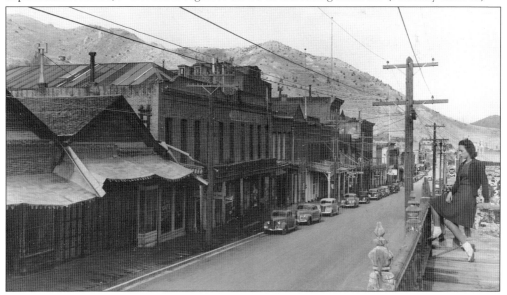

Mulcahy photographed a young lady sitting on an old balcony in the 1940s. She seems to contemplate a Virginia City that looked to the past without a clear image of the future. Residents from the period often recall a place cut off from the excitement of larger cities. Tourists remember a town that held on to the past in a special way. (Mulcahy-CHDC.)

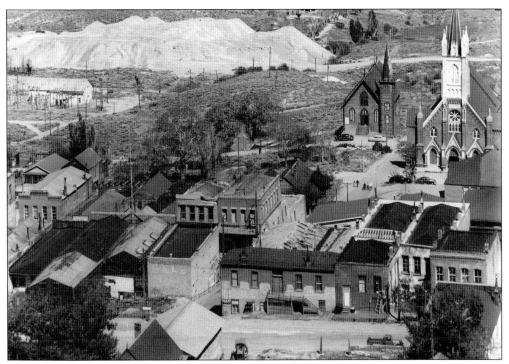

The hills around Virginia City have afforded photographers with an excellent vantage for nearly 150 years. A massive mine dump in the background bears witness to the industry that made the Comstock great. Two churches stand vigil, tending to those who remained in the mid-20th century. (Mulcahy-CHDC.)

From left to right, locals Ben Wade, Joe Colletti, and John Bowie pose in front of a Storey County Fire Department truck in this undated photograph. Fire had destroyed much of Virginia City throughout its history, but the community consistently rebuilt itself. By the mid-20th century, firefighters simply tried to save the historic relics that still stood.

The Virginia Garage, shown here around 1950, incorporated the historic building on the right. The owner transformed it into a repair shop, its old storefront knocked out to accommodate automobiles. Since World War II, Virginia City has at times lacked a gas station, making life on the Comstock a logistical challenge. (Mulcahy-CHDC.)

Mulcahy photographed longtime druggist Paul Coryell and an assistant in the 1940s. The Pioneer Drug Store on C Street in the center of town served residents for decades. Ironically, the improved roads that allowed tourists to arrive in increasing numbers also extinguished many local businesses, as residents could travel to Reno or Carson City for shopping. (Mulcahy-CHDC.)

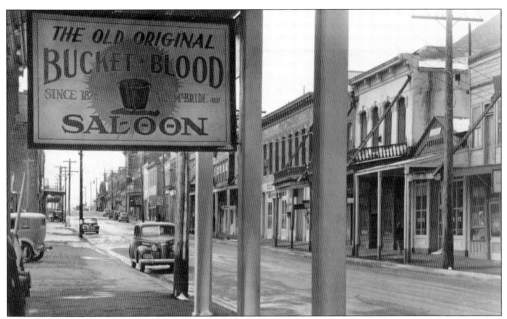

A winter day became the backdrop for Mulcahy's photograph of Virginia City's C Street. A sign for "The Old Original Bucket of Blood Saloon" dominates the boardwalk on the left. Although the sign states the saloon dated to 1876, the McBride family founded the institution in the early 1930s. The core of the building dates to the 1860s but was remodeled after the 1875 fire. The Bucket of Blood remains one of rural Nevada's favorite rest stops. (Mulcahy-CHDC.)

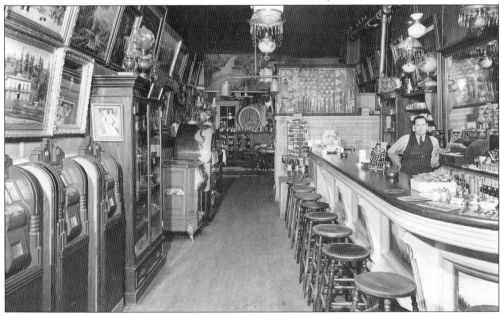

The interior of the Bucket of Blood Saloon included antiques ranging from paintings and photographs to crystal lamps. Slot machines on the left stood ready for customers who wished to step away from the bar. The McBrides were among the first to understand the potential of marketing the Wild West side of Virginia City to tourists. Eventually the owners knocked out the center wall on the left to enlarge the bar. (Mulcahy-CHDC.)

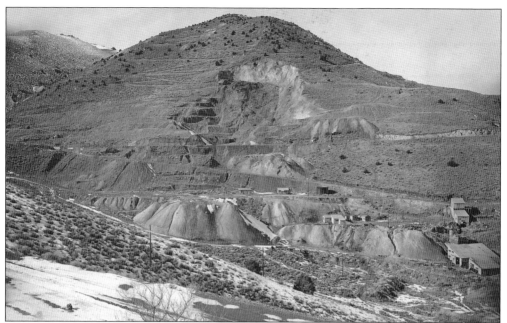

Mulcahy used a telephoto lens during the mid-20th century to capture this image of the ruined Mexican Mill on Cedar Hill rising above Virginia City to the north. The natural contours of the hillside bear the scars of decades of mining. Virginia City was transforming into a tourist destination, in part because reminders of its glorious days as a mining capital survived for everyone to see. (Mulcahy-CHDC.)

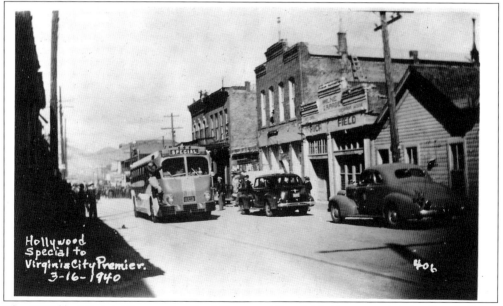

The 1940 film *Virginia City* starring Errol Flynn and Randolph Scott premiered at Piper's Opera House. A special excursion bus arrived with stars and reviewers for the event. Eastern social and theater critic Lucius Beebe hated the movie but fell in love with the town. After the war, Beebe moved to Virginia City with his partner, Charles Clegg. They resuscitated the *Territorial Enterprise*, preserved some structures, and elevated local culture.

A book signing at the Delta Saloon in August 1949 included such notables as Duncan Emrich, director of the Library of Congress Folklife Department (left), author Walter Van Tilburg Clark (kneeling), poet Irene Bruce (seated), and author Lucius Beebe (right, with striped coat). Beebe and his companion, Charles Clegg, transformed Virginia City into a literary destination, but they left in disgust after the arrival of *Bonanza*-inspired tourists. (SHPO; courtesy of the late Don McBride.)

In 1959, Vice Pres. Richard Nixon helped dedicate a centennial marker in the center of Virginia City commemorating the first 1859 strike. His wife, Pat, was a Nevada native, a daughter of the mining frontier that developed as a consequence of the Comstock discovery. The monument dedicated that day still stands in the Delta parking lot in the center of town. Also present were daughters Tricia (far left) and Julie (second from left).

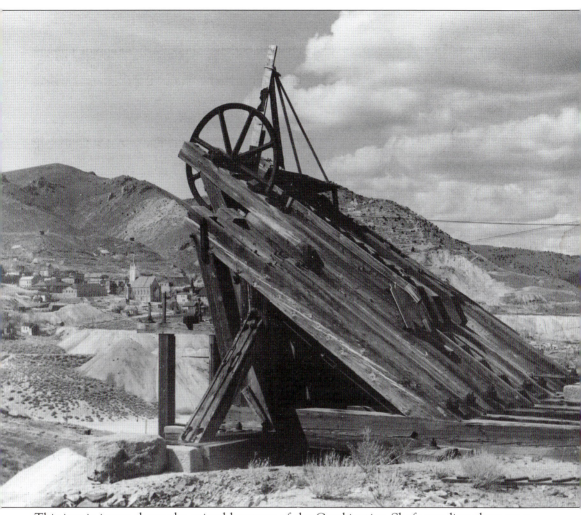

This iconic image shows the ruined keystone of the Combination Shaft standing alone on a ridge overlooking Virginia City. Remnants of the past, surviving in the dry, high mountain environment, contribute to making the Comstock Historic District one of the largest and more remarkable National Historic Landmarks. (Mulcahy-CHDC.)

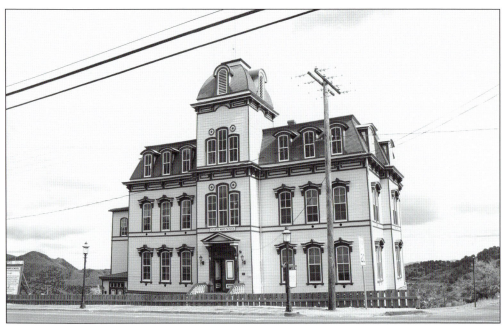

Partial proceeds from the sale of this book benefit the Historic Fourth Ward School Museum. The museum has won recognition from the National Trust for Historic Preservation and the Save America's Treasures program, a White House initiative. Grants from the Nevada Commission for Cultural Affairs have transformed an abandoned building into a state-of-the-art restoration project. More information about the museum may be found at www.fourthwardschool.org. (JAMES.)

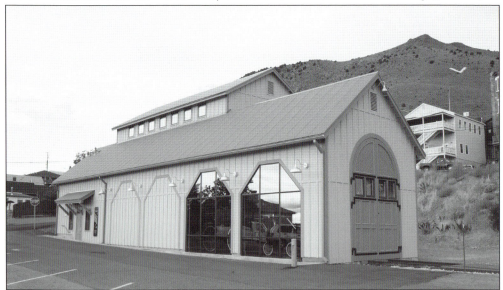

Founded in 1969, the Comstock Historic District Commission encourages the preservation of buildings within the National Landmark. The agency is part of the Nevada Department of Cultural Affairs. Since 1993, the commission has cooperated with the State Historic Preservation Office to excavate archaeological sites and to discourage the destruction of the remarkable resources that linger on or beneath the ground. The commission has operated the Comstock History Center since 2005. Go to www.nevadaculture.org. (JAMES.)

BIBLIOGRAPHY

De Quille, Dan (William Wright). *The Big Bonanza*. New York: Alfred Knopf, 1947; reprint of the 1876 original.

Drury, Wells. *An Editor on the Comstock Lode*. New York: Farrar and Rinehart, 1936.

James, Ronald M. *The Roar and the Silence: A History of Virginia City and the Comstock Lode*. Reno: University of Nevada Press, 1998.

James, Ronald M., and C. Elizabeth Raymond. *Comstock Women: The Making of a Mining Community*. Reno: University of Nevada Press, 1998.

James, Susan A. *Virginia City's Historic Fourth Ward School: From Pride to Glory*. Virginia City, NV: The Fourth Ward School Museum, 2003.

Lord, Eliot. *Comstock Mining and Miners*. San Diego: Howell-North Books, 1959; reprint of the 1883 original.

Smith, Grant, with new material by Joseph V. Tingley. *The History of the Comstock Lode, 1850–1997*. Reno: Nevada Bureau of Mines and Geology in association with the University of Nevada Press, 1998.

Discover Thousands of Local History Books
Featuring Millions of Vintage Images

Arcadia Publishing, the leading local history publisher in the United States, is committed to making history accessible and meaningful through publishing books that celebrate and preserve the heritage of America's people and places.

Find more books like this at
www.arcadiapublishing.com

Search for your hometown history, your old stomping grounds, and even your favorite sports team.

Consistent with our mission to preserve history on a local level, this book was printed in South Carolina on American-made paper and manufactured entirely in the United States. Products carrying the accredited Forest Stewardship Council (FSC) label are printed on 100 percent FSC-certified paper.

MADE IN THE USA